NOTE ABOUT THIS SERIES

TO GET HOLD OF THE INVISIBLE, ONE MUST PENETRATE AS DEEPLY AS POSSIBLE INTO THE VISIBLE. THIS IS THE ESSENCE OF PAINTING. § THE ARTIST MUST FIND SOMETHING TO PAINT. PAVEL TCHELITCHEW SAID, "PROBLEMS OF SUBJECT-MATTER HAVE BEEN LIKE OBSESSIONS — IMAGES HAVE HAUNTED ME SOMETIMES FOR YEARS BEFORE I WAS AT LAST ABLE TO UNDERSTAND WHAT THEY REALLY MEANT TO ME OR COULD BE MADE TO MEAN TO OTHERS." THESE ESSENTIAL IMAGES AND THEMES IN A BODY OF WORK — PEOPLE, PLACES, THINGS — ARE EQUIVALENTS OF THE ARTIST'S INNER, INVISIBLE REALITY. § THE ARTBOOKS IN THIS SERIES EXPLORE SPECIFIC SUBJECTS THAT HAVE MOVED CERTAIN ARTISTS AND STIRRED OUR DEEPEST RESPONSES.

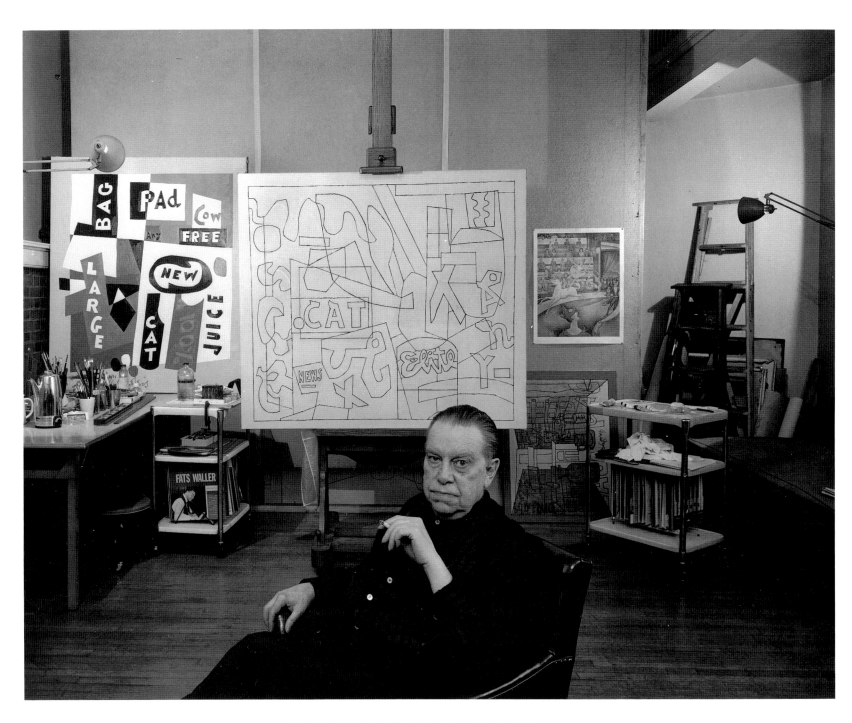

Stuart Davis, New York City, 1957, photograph by Arnold Newman

A CHAMELEON BOOK

STUART DAVIS'S ABSTRACT ARGOT

William Wilson

POMEGRANATE ARTBOOKS, SAN FRANCISCO, CALIFORNIA

A CHAMELEON BOOK

Published by Pomegranate Artbooks
Box 6099, Rohnert Park, California 94927

Produced by Chameleon Books, Inc.
211 West 20th Street, New York, New York 10011

Creative director: Arnold Skolnick
Managing editor: Carl Sesar
Editorial assistant: Lynn Schumann
Composition: Larry Lorber, Ultracomp
Printer: Oceanic Graphic Printing, Hong Kong

Library of Congress Cataloging-in-Publication Data

Wilson, William (William R.)
 Stuart Davis : abstract argot / William Wilson
 p. cm. — (The Essential paintings series)
 "A Chameleon book."
 Includes bibliographical references.
 ISBN 1-56640-316-2
 1. Davis, Stuart, 1892 – 1964 — Criticism and interpretation.
2. Painting, Abstract — United States. I. Title. II. Series.
ND237.D333W55 1993
759.13 — dc20 93-4338
 CIP

FOR CYNTHIA

ACKNOWLEDGMENTS

I would like to thank Arnold Skolnick, the director of Chameleon Books, for the opportunity to write about one of our favorite artists. I'm grateful to Carl Sesar, who edited the book with deep thought and a light touch; my friend Tim Rutten, who read the manuscript; and Thomas Burke, publisher of Pomegranate Artbooks, who made the book a reality.

William Wilson

I am very grateful to Earl Davis for reading the manuscript, shedding light on several points of fact, and supplying us with a number of images. We are also indebted to the staff at Salander O'Reilly Gallery for their cooperation and invaluable assistance. Last but not least, thanks are due to all the public collections that supplied us with the fine transparencies for this book.

Arnold Skolnick

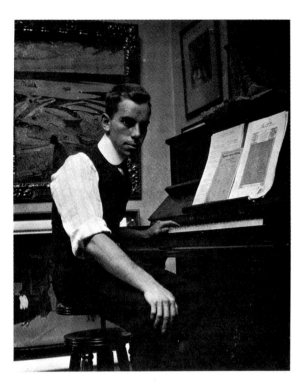

Stuart Davis at the piano

STUART DAVIS'S LONG CAREER ended in New York on June 24, 1964, when he died at age 71 of a heart attack. Before it was over he'd learned to drink like a fish, smoke like a dragon, scrap like a junk-yard dog, politick like a ward-heeler and to become an addict of black jazz in clubs so tough the piano was fenced with barbed wire.

Not just incidentally, he also painted paintings. To this day they remain modern, singular, slangy, syncopated. Animated by the spirit of American populist idealism, the work has caused Davis to be rightly compared to Walt Whitman and George Gershwin for his aesthetic singularity and evocation of the American spirit. The flavor of his art expresses itself in staccato titles like *Rapt at Rappaports, Owh! in San Pao,* and *The* **26, 25** *Mellow Pad.* They are like drum raps, sax riffs and tickled ivories. His colors blink **22** and flash like neon. His shapes look like eccentric swatches left on a garment factory floor.

"I was a Cubist till somebody threw me a curve," he once quipped.

Like Cézanne, he started as a scruffy expressionist and ended as a controlled innovator. He was one of those rare artists who summed up everything that came before him and transformed it so radically that nothing that came after quite makes sense without taking him into account. Everybody talks about how he distilled American jazz into painting, but he did more. He got the feel of the American animated cartoon into still pictures. He transformed Lucky Strike packs, rubber gloves, and the argot of advertising into the concrete poetry of visual jive. He gave French Modernism a breezy Manhattan accent and civilized the energy of American popular culture. And yet there have been times when Davis was regarded as passé and irrelevant. So much for fashion.

He was born in Philadelphia on December 7, 1892. His mother Helen was a sculptor, his father Edward an artist and art director for the *Philadelphia Press.* With such parents Stuart was unlikely to suffer the common rap about artists being sissies. In a short autobiography published in 1945 he wrote, "It is not unusual for artists to dwell on the obstacles they have had to overcome before gaining opportunity to study. But I am deprived of this satisfaction because I had none."

But apparently this classic American Modernist, like many a regular guy, did need and find things to rebel against—saturnine grinding stones to shape his individuality. Born into a time of deep economic depression, Davis inherited a social conscience in the cradle. The Gay Nineties were only fun for a tiny minority of wealthy Americans. Most citizens were still poor farmers, their spiritual options suddenly limited by the official closing of the American frontier. The country struggled with the excesses of the robber barons. Society seemed out of control. Across the land middle-class reform movements bespoke unrest. An American Socialist party gained ground.

The union movement, viewed with suspicion as an alien import of immigrants and anarchists, was at its beginnings. In 1892 Henry Clay Frick had been shot and stabbed by an anarchist during a Pennsylvania steel strike in which strikers and Pinkerton men hired by Frick exchanged fire, killing men on both sides. (People rarely think of this when visiting the patrician Frick collection of old masters on Manhattan's Fifth Avenue.) Eugene Debs ordered his railway workers to walk out and was indicted for

interfering with the mails. Federal troops were ordered into Chicago to break the strike. Coxey's pitifully small "army" of 400 unemployed marched on Washington, D.C.

In those days news stories were illustrated with on-the-spot drawings by quick sketch artists. Among the cheeky stable of fast-drawing journalist-illustrators working for Davis's father were George Luks, William Glackens, Everett Shinn, and John Sloan, who eventually became young Stuart's mentor and part of the group variously known as "The Eight," "The Philadelphia Black Gang," and finally, "The Ashcan School."

The crew around the paper were also painters deeply influenced by one of American art's great teachers, the painter Robert Henri, who espoused the depiction of genre subjects reflecting contemporary reality. Davis later paraphrased Henri's aesthetic philosophy thus: "To hell with the artistic values. What we want are your own fresh reactions to what you see...." True to their mentor, his followers were artistically fascinated with urban street life, the hookers, drunks and innocent poor that inhabited the underbelly of immigrant America. Ebullient observers rather than reformers, the artists did still limn an America in social crisis.

In 1901, when Stuart was 9, the family moved to East Orange, New Jersey, where dad had landed a job as art editor of the *Newark Evening News*. Talented and precocious, after two years of high school Stuart dropped out and went to study painting with Henri in New York. "For the novitiate," he recalled, "acceptance on an equal footing with the other members involved the purchase of large quantities of beer." But for Davis himself, this was not enough. Highly competitive, in an artistic face-off with his mentor, he painted a snowscape similar to a well-known canvas by his teacher and was proud that people thought it was better.

Davis's youth was pocked with wrangles. Some were about expressive freedom and social justice. Others were just the natural acts of a young dude who was as aggressive and belligerent as he was stubborn, funny, and utterly opposed to pomposity and cant. The principal symbol of all that would be his endless feud with his artistic rival, Thomas Hart Benton.

One day in 1912 an artist chum brought another painter around to the studio where Davis was sketching. The 18-year-old Stuart was very high on his own work and held forth in smart-alecky accents the visitor found obnoxious. He was Benton, 23, just returned from Paris, where he'd drunk, brawled, had a tawdry affair, and also studied the advanced art movements of the day through friendships with the Synchromists Morgan Russell, Stanton MacDonald-Wright and Diego Rivera, then a Cubist. Benton cut off Davis's monologue with, "Go to Paris and try to learn something."

The corrosive encounter sparked lifelong friction between two men who were, at bottom, very much alike. Davis had begun as a realist who, within a year after his encounter with Benton, couched his imagery in Modernist abstract form, almost as if he were following his rival's advice. Benton, as if he'd glimpsed something important in Davis's realism, returned to it, creating the Regionalist movement that eventually dominated American art in the 1930s and for a time eclipsed Davis's work.

Stuart Davis, CONSUMERS COAL CO., 1912
Oil on linen
Collection of Sunrise Museum, Charleston, West Virginia

Stuart Davis, CATS, 1913
Drawing reproduced in *Harper's Weekly* 58
September 6, 1913, p. 9

Stuart Davis, THE FRONT PAGE, 1912
Watercolor, 11 x 15 inches
The Museum of Modern Art, New York, Purchase

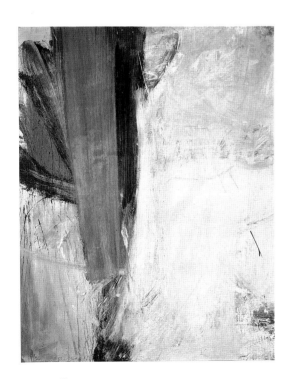

Willem De Kooning, MONTAUK HIGHWAY, 1958
Oil on canvas, 59 x 48 inches
Los Angeles County Museum of Art
Gift of the Michael and Dorothy Blankfort Collection
In honor of the Museum's 25th Anniversary

By 1913, the wunderkind Davis was already illustrating for the liberal popular press. He first worked for the Socialist-oriented *The Masses* along with John Sloan, George Bellows and others. *Masses* editors tended to be social activists who felt that simply printing a drawing of life in the American underbelly did not sufficiently indoctrinate readers. The prospect of having politically oriented captions and titles added to his work threatened Davis's sense of artistic freedom. Unwilling to be turned into a propagandist, Davis resigned. This set a pattern for his attitude toward the relationship between art and politics, which had some contradictions. Though he came to believe passionately in Marxism, he never became a Communist Party member. His stand was essentially about social justice for the poor and disenfranchised, including artists, but he believed that art should always remain free of direct political or ideological propaganda.

Davis, working in a style that echoed fin de siècle Art Nouveau, was also at the time especially attracted to scenes of street-walkers like *Cats*. In his painting, he made curious, rather Munch-like bedroom dramas like *The Front Page,* suggesting sexual tension and frustration.

The same year an event occurred that at a stroke turned Davis's life around.

He saw the Armory Show.

The now legendary exhibition opened in New York on February 17th at the 69th Street Armory. It introduced the larger American public to the advanced art of Europe in some 1,600 works that included a cross section of contemporary American art and a heavy representation of the school of Paris from Cézanne to Picasso and, of course, the *succès de scandale* of the whole affair, Marcel Duchamp's *Nude Descending the Staircase.*

The show, which also traveled to Chicago, had been organized with extraordinary selflessness and breadth of vision by artists around the larger Henri circle, principally the painter and printmaker Arthur B. Davies. Stuart Davis himself was represented by five watercolors. The show opened to great scorn and controversy in the popular press, but the American artists, by their own generosity of spirit in organizing an exhibition that did nothing to promote their own aesthetic, had succeeded only in turning themselves into dinosaurs. Their work, modern only in subject, belonged to the 17th century, to the style of Frans Hals.

Writing of the Armory Show's impact, Davis said, "I also sensed an objective order in their works which I felt was lacking in my own. It gave me the same kind of excitement I got from the numerical precision of the Negro piano players...and I resolved I would definitely have to become a 'modern' artist."

For the next decade Davis set about reinventing himself. The artist discovered Gloucester, Massachusetts, in 1915 and summered there regularly until 1934. (He was such a city kid that on his first visit he went rowing and then tied the boat to a piling next to his digs. The next morning it hung perpendicularly. The tide had gone out.) He painted landscapes, among them *Gloucester Beach/A Cove (Rockport Beach).* **1** This work represented a breakthrough in loosening up his brushwork and composition. Its bucolic mood and casual Modernism recalls Pierre Bonnard. The perspective, flattening from the bird's-eye view, anticipates such abstract landscapes as Willem de

Kooning's *Montauk Highway.*

In other works Davis acted out his admiration for artists seen in the Armory Show.
2 In *Studio Interior* he painted a scruffier version of Matisse's elegant *The Red Studio.*
5 His *Still Life (Red)* is a gloss on Matisse. He painted a portrait of himself as if he
3 were Chaim Soutine thinking about Vincent Van Gogh thinking about Paul Gauguin.

In 1917 he held his debut solo show at the Sheridan Square Gallery in New York, where he'd established a studio. During World War I he served briefly as a cartographer. After it was over he hied off to Cuba for a sojourn where he witnessed knife fights, met agreeably aggressive girls, became tangled in portentous language mix-ups, and discovered a pig that lived in a bathtub. All this led to some hot watercolors that suggest some quality useful in his later understanding of the overlap between form and rhythm.

4 In the early 1920s he painted images of cigarette packs that would later be seen as seminally original to his own aesthetic and predictive of 1960s Pop Art. They first established his interest in the distillation of popular culture and in a collage-like approach to composition that would eventually dominate his work. The young artist himself, however, struggling through an eclectic phase, failed to recognize the significance of what he had achieved.

He summered in New Mexico in 1923 and did some good work there, but didn't like the Southwest much. "The place is always there in such a dominating way. You always have to look at it."

His sophistication deepened through friendships with Charles Demuth, the poet William Carlos Williams, the brilliant Russian emigré eccentric John Graham, and the soulful Armenian avant-garde comer Arshile Gorky. With Davis, the latter two became "The Three Musketeers."

The year 1927 was a crossroads for Davis. He had a growing reputation as a young avant-garde turk. But he himself, increasingly fastidious about his own work, was not satisfied. So he set himself an act of rigid self-discipline. "I nailed an electric fan, a rubber glove and an egg-beater to a table and used it as my exclusive subject matter for a year. The pictures were known as the Eggbeater series and aroused some interested comment in the press even though they retained no recognizable reference to the optical appearance of this subject matter."

Among the first fruits of Davis's involvement with these simple utensils were
11 *Egg Beater No. 3* and *Egg Beater No. 4.* These compositions reduce their common-object sources to pure planes, and their antic use of space suggests that although Davis rejected Surrealism, its abstract master, the Catalan Joan Miro, appears to have been in the American's thoughts.

Davis's pungent, slightly wall-eyed sense of humor, and his affection for common-place Americana, show in the Dadaesque selection of subject matter seen in the works
7, 8 leading to the Eggbeater series, *Edison Mazda* and *Odol.* Later there is a Dadaesque
14, 15 quality to works like *Salt Shaker* and *Still Life: Radio Tube.* It seems curious that Davis was able to combine humor with precision until one reflects that humor must be precise and that attempts at precision are inherently absurd.

The theme-and-variation concentration of the Eggbeater project shows him

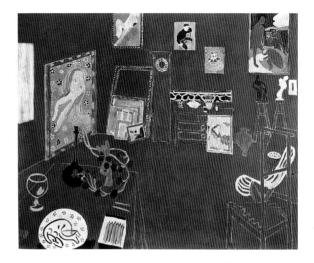

Henri Matisse, THE RED STUDIO, Issy-les-Moulineux (1911)
Oil on canvas, 71¼ x 86¼ inches
The Museum of Modern Art, New York
Mrs. Simon Guggenheim Fund

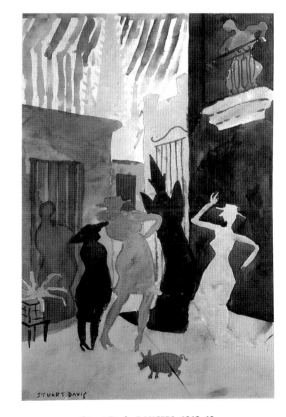

Stuart Davis, DANCERS, 1918–19
Watercolor on paper, 22¾ x 15⅝ inches
Courtesy of Salander O'Reilly Gallery

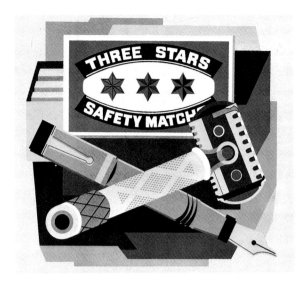

Gerald Murphy, RAZOR, 1922
Oil on canvas
32⅝ x 36½ inches
Dallas Museum of Fine Arts
Foundation for the Arts Collection
Gift of the artist

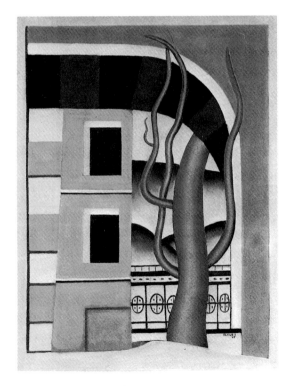

Fernand Leger, TREE, 1925
Oil on canvas
Sprengel Museum, Hannover

headed for the high degree of planning and calculation required to make his images look both inevitable and spontaneous. He would eventually leave nothing to chance except chance itself, preplanning with drawings that mapped his paintings down to the last scintilla. This combination of the pristine and the popular brings to mind the work of Gerald Murphy, who was mining a similar vein.

The ruminative duration of the Eggbeater project hints at Davis's leanings to theory. Out of these works came voluminous writings on art in articles, journals, daybooks, critical reviews and broadsides. Some, such as "What Abstract Art Means to Me," tend to function as blasts against what Davis called "Subjective" art. "Art is not a subjective expression to me, whether it be called Dadaism, Surrealism, Non-Objectivism, Abstractionism, or Intra-Subjectivism. But when paintings live up to these Advance Agent Press Releases, I turn on the Ball Game."

In ordinary terms we tend to think of Davis's own art as abstract but, like that of Picasso, it virtually always has subject matter. Unlike that of Picasso, however, its personal and autobiographical content is masked, marking Davis as a man who preferred to keep his psyche to himself.

The cultural activist side of Davis wrote tracts like "Federal Art Projects and the Social Education of the Artist," in which he made early arguments against the elitist character of the art world. Artists, he said, "fought and plotted among themselves for the favor of the museum prize. This attitude has been very destructive to artistic progress as well as to the economic stability of the artist stratum, because their individualistic theory has left them wide open to commercial exploitation of the lowest and most wasteful order." He went further to praise the Federal Art Project of the Great Depression for having raised artists' social conscience.

Along the way, he acquired a dealer in Edith Halpert, whose Downtown Gallery would represent Davis's work for much of his career, with occasional interruptions by squabbles, usually over money. Then a real stroke of good luck. The influential Juliana Force of the Whitney Studio Club bought two paintings, which provided enough bread for Davis to travel. One can't help wondering if Benton's sarcastic advice was in his mind when Davis said, "Having heard it rumored at one time or another that Paris was a good place to be, I lost no time in taking the hint."

He arrived in June 1928 to find the place suited him. He loved the cafes and peaceful absence of Gotham bustle. Interestingly, the Louvre left him cold. He met Gertrude Stein, and hung around with Marsden Hartley, Niles Spencer, Elliot Paul, Bob Brown and other local expatriate intelligentsia. Among his most significant encounters was a visit to the studio of Fernand Leger. Strong temperamental affinities bound the work of the two artists. One can see some of this in Davis before his Paris visit in *Early American Landscape*. **9**

His attempts to learn French proved fruitless. "The bloody Frenchmen don't even understand each other so what chance have I got?" This did not, however, prevent him from using bilingual puns in later works like *Tropes de Teens*. **30**

The work he produced in Paris reflected a lyric mood. Davis was so charmed and relaxed his cheek gave way to chic. But compositions like *Rue Lippe* are worthy of an American in Paris with their eye for the telling detail. The proto-Pop drinking

apparatus in the foreground is surely meant to be humorous, since there is no Rue Lippe in Paris. The reference is to the legendary Brassierie Lipp on Blvd. St. Germaine. For Davis, who liked to hang out at the place, the street became "Rue Lippe" in his head. "It's a swell place," he wrote. "I just came from there 6 or 7 times in the last 48 hours and expect to go back this afternoon."

Certainly another reason for Davis's sunny frame of mind in the city of lights was the fact that he didn't have to search for girlfriends. He'd taken one with him. Her name was Bessie Chosak. Little is recorded of her. Davis's family disapproved of her which, knowing his temperament, likely made her all the more attractive. She and the artist were married in Paris.

Such central life experiences always teach more than one thing, but among Davis's epiphanies in France was "to spike the disheartening rumor that there were hundreds of talented young modern artists in Paris who completely outclassed their American equivalents. It allowed me to observe the enormous vitality of the American atmosphere as compared to Europe and made me regard the necessity of working in New York as a possible advantage."

Retrospective thoughts of his youthful year in Paris would stay on Davis's mind 32 for the rest of his life. In 1959 he reworked *Rue Lippe* as *The Paris Bit*. It replaces the charming funk of 1928 with dynamic sophistication. Davis was surely making a point with the red, white and blue color scheme that is shared by Old Glory and the French tricolor. An incipient edge of nostalgia is deepened knowing the painting is a memorial to his old Paris crony, writer Robert Carlton Brown.

28 Earlier, in 1954, Davis had already painted *Colonial Cubism,* and he wrote to his

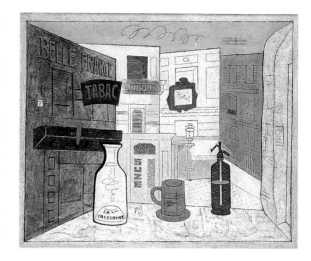

Stuart Davis, RUE LIPPE, 1928
Oil on canvas, 32 x 39 inches
Andrew Crispo Collection

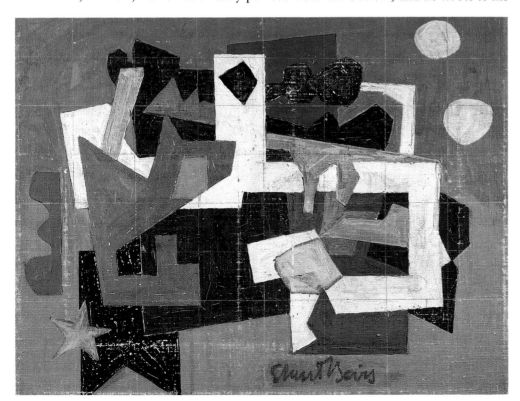

Stuart Davis, STUDY FOR COLONIAL CUBISM, 1954
Oil on canvas, 12 x 16 inches
Courtesy of Salander O'Reilly Gallery, New York

dealer Edith Halpert, "I am strictly a European (French, that is) man myself, although forced by birth and circumstances to live in the American Art Desert as exile. And then of course the Europe I mentally dwell in no longer exists in actuality." This is an assertion remarkable for its apparent lack of self-knowledge, but it does indicate the important role Davis assigned the influence of French art in his own work. But without New York, Stuart Davis would have been remembered as a painter lacking the essential Gotham grit that made him great.

Davis and his wife Bessie returned to the States in August 1929, completely tapped out from the year abroad, and just in time for the Great Depression. It surely did nothing to ease Davis's state of mind when, the same year, Robert Henri died.

Davis nonetheless found his smoldering social conscience ignited. He became a front-line organizer for reform, even though his activism kept him out of the studio. He joined the fledgling Artists Union and edited its broadside newspaper *Art Front,* where he demanded that artists be treated like other workers, receiving union-scale pay and social insurance. He called for government support of artistic projects without interference and, naturally, joined the WPA when President Roosevelt launched the historic Federal Arts Project program. Later, Davis became one of the original founders of The American Artists Congress and served as its national chairman.

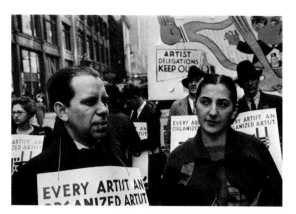

Stuart Davis and Roselle Springer at May Day parade, 1934, photograph by Ben Shahn

During the Depression era the perception of art became politicized, as it tends to do in hard times. America, anxious for its own security and frightened by the spectacle of a Europe wracked by anarchy and Bolshevism, no longer saw avant-garde ideas as exciting as they seemed in the heady 1920s. Abstract art became identified with the international Communist conspiracy. The reasons for this vary, and people tend to generalize. They assume radical art equals radical ideas. Many Modernist artists did in fact identify with extreme ideals of the epoch, including Fascism as well, as for example the Italian Futurists under Mussolini. And in Russia, avant-garde artists were embraced by the Bolsheviks until Lenin and Stalin, deciding that Socialist Realism would speak more clearly to the masses, squashed the vanguard like so many bugs.

In 1934, amid Davis's fervidly militant social activism, Bessie Chosak died of peritonitis following a botched abortion. It is no accident that during this period Davis's work for once tips its hand emotionally, reflecting horror, anger and depression. A work called *Mural: (Men Without Women)* was the first commission to **17** come Davis's way after Bessie's death. It was done for the men's lounge at Radio City Music Hall. Made up of the emblems of men's quotidian pleasures, there is a disturbed, tense aura about the compositon. If Davis was grieving he tried not to show it. "It has to be done by Nov. 1 or I lose $1000 a day in publicity money," he wrote. "I hope everything comes out alright and that I will once again be in position to quaff the tasty and stupifying [sic] McSorley's ale."

Davis put up a good front, but paintings of the period tell a deeper story. *Abstract Vision of New York: a building, a derby hat, a tiger's head and other symbols* **16** *(New York Mural)* positively invites psychological analysis. Made for an exhibition at the Museum of Modern Art, it is a jingoistic protest against the great Mexican painters, like Diego Rivera, getting the lion's share of mural commissions. Its palette lends a Miro-like note of the sinister to Davis's angry sarcasm. The derbies allude to

one of Davis's heros, the politician Al Smith. But fundamentally they are symbols of masculinity, as are the phallic bananas below. One is castrated. Executed around the time of Bessie's death, this painting's symbols of ferocity and vulnerability may provide a rare glimpse into Davis's carefully guarded subconscious.

By 1938 Davis's work cheered considerably. Although a nominal abstractionist frankly aligned with the left, he executed a number of government-sponsored murals under the WPA without overt incident—probably because the work had no direct political content.

18 One example, *Swing Landscape,* is as lyrical as its amiably punning title. Originally commissioned for a WPA Brooklyn housing development, it was never installed, but the manner of its assignment showed the tone of Federal Art projects. The mural section was headed by painter Burgoyne Diller, who handed out commissions to his fellow abstract artists. Most were given to figurative painters, based on the notion that the average citizen didn't dig abstract art, but Diller, believing that the shapes and colors would have a salubrious effect on residents, commissioned his friend Davis anyway. The result is a wonderful, syncopated montage of a harbor with all the color and breezy excitement of a regatta.

In contrast to Davis's situation, American isolationism of the time created history's moment for Regionalist master Benton and such colleagues as Grant Wood and John Steuart Curry. Theirs was an art perfectly suited to a country in a withdrawn mood— accessible and celebratory of the American myth, albeit sometimes in rather sour accents.

It cannot have been comforting to Davis's considerable ego when both he and Benton were on the faculty together, first at the Art Students League, and then at the New School for Social Research, where Benton had painted a series of murals. In 1935 Davis's bête noir had his self-portrait on the cover of *Time* magazine accompanied by a favorable article on the Regionalists. Davis responded with a piece in *Art Front* saying, "Are the gross caricatures of Negroes by Benton to be passed off as 'direct representation'? The only thing they represent directly is a third-rate vaudeville character cliche with the humor omitted."

Davis had reference to Benton's somewhat caricature-like style. In touchy times a painting like Benton's *Romance* could be taken as a visual racial slur, but anyone with the slightest reflection would notice that Benton exaggerated the features of all his subjects equally. Davis's innuendos have a built-in boomerang effect, causing us to remember that he himself drew images of blacks in his Ashcan period that are open to the same distorted interpretation.

Public confrontations between the rival artists were carried on in the press and at various lectures. Despite self-righteous rhetoric, one can detect personal animosity and careerism at work on both sides. Davis—who tended to look like a slick-haired movie gangster in the 1930s—planted strong hints that Benton was both a racist and an anti-Semite. He was neither. But the heavily left-wing Manhattan art cell escalated the slur of racism into an accusation that he was a Fascist, citing, among other things, Benton's silence over the notorious suppression of a Diego Rivera mural at Rockefeller Center. Benton was not a Fascist either. But he may have been a homophobe: as a result of

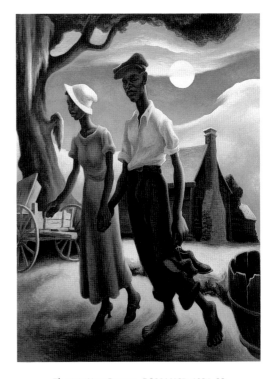

Thomas Hart Benton, ROMANCE, 1931–32
Tempera and oil varnish glazes on gesso panel
45¼ x 33¼ inches
Archer M. Huntington Art Gallery
The University of Texas at Austin
Gift of Mari and James A. Michener
Photograph by George Holmes

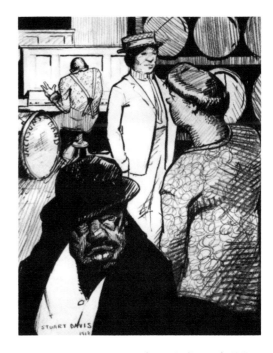

BARREL HOUSE NEWARK (JACKSON'S BAND), 1913
Pencil, ink and crayon on paper
19 x 15⅜ inches
Private collection

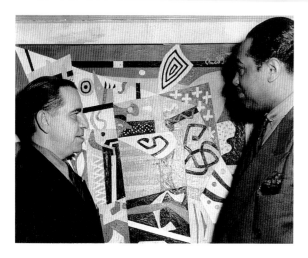

Stuart Davis with Duke Ellington

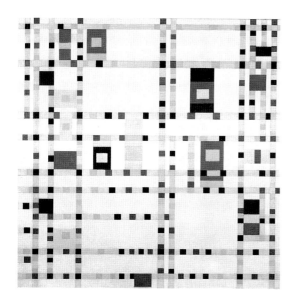

Piet Mondrian, BROADWAY BOOGIE WOOGIE, 1942–43
Oil on canvas, 50 x 50 inches
The Museum of Modern Art, New York
Given anonymously

the controversy he left New York permanently to live and teach in the Midwest, grumbling that modern artists were a bunch of "pansies."

Davis loved a good scrap, so Benton's departure probably tickled him. The pleasure didn't last. Davis was horrified by events in Europe—Russia's invasion of Finland, the nonaggression pact between Hitler and Stalin, growing evidence of Uncle Joe's crimes against his own people. Davis quit the American Artist's Congress in 1940 and began a wrenching reevaluation of his work and his ideals.

"There is nothing like a good solid ivory tower for the making of art," he concluded.

Before he closed the door he allowed Roselle Springer into his citadel. They married in 1938 and had a son, George Earl, born in 1952 when Davis was 60. The artist was never again politically active. During World War II and after he taught, exhibited, and stayed working in the studio, often refining old themes while a sporting match played soundlessly on television. In the evening he ventured out to hoist a couple and listen to some jazz. "My wife Roselle and I merely go out the front door and bear to the left. After a healthy walk of two blocks we dive into a joint where the great Earl Hines is sadistically murdering a piano."

His work of the 1940s tended to become smaller, more ornate, and almost compulsively complex. Compositions like *Arboretum by Flashbulb* show Davis reaching **20** for a new synthesis after his withdrawal into the studio. Elements of the work are so fractured as to minimize his usual allusions to subject matter. Instead the abstract elements jell into a unity. Its elaborate geometric pattern is a rational anticipation of concerns that would preoccupy the Abstract Expressionists intuitively. They introduced a sense of shapes pushing and pulling against the flat surface of the painting. Jackson Pollock, who was clearly on Davis's mind during this time, was painting works that the viewer sees all at once rather than in parts, as had been traditional in Western art. Grappling with the problem of Pollock's "new" space was a concern of Davis's in *The Mellow Pad*. Even though Davis rejected action painting, he was too **22** intelligent not to realize that all art fundamentally shares the same concerns. In fact, he'd already paid homage to the Dutch pioneer purist, Piet Mondrian, in *G&W*. **21**

Ebullient virtuosity was fully solidified in Davis's oeuvre with the wonderful 1952 *Rapt at Rappaports*. It fixed a set of colors that he would vary and use numerous **26** times. In it, dots, dashes and squiggles play counterpoint to larger scraps. The onomatopoeic title, boldly lettered across the bottom, puns as much as the abstract shapes. "Rapt" could also be "wrapped" or, because the "t" is a different color, "Rap" as in a drumbeat, a hip conversation, or current popular music. Davis's fellow American original Edgar Allen Poe would have been proud of him. So would Baudelaire and the other French Symbolist poets who started the Modernism that so influenced Davis.

Davis occupied an odd position on the conveyor belt of time. He was significantly younger than the avant-garde around Alfred Steiglitz's Gallery 291, whose Marins, Demuths, Hartleys and O'Keeffes pioneered advanced ideas even before the Armory Show. To them he was always a young hotdogger. Now, to the crowd around the Cedar Bar, cradle of Abstract Expressionism, Davis was a slightly older guy, to be

respected, but a bit over the hill for their aesthetic. He lost a lot of friends among them when they evolved the intensely personal and spontaneous action painting that would bring American art to international leadership after World War II.

Davis called it "a belch from the subconscious."

He was like a man who never knew middle age, going straight from pistol to distant and fixed star in the firmament—as singular a person in his time as Copley, Eakins, and Ryder had been before him.

For the rest of his life the honors piled up in a satisfying heap. In 1945 the Museum of Modern Art accorded him a retrospective. In 1952 and 1956 he represented the nation at the Venice Biennial. Elected to the National Institute of Arts and Letters. A 1957 retrospective at the Walker Art Center. A long string of medals and awards.

In the end Davis received the best the art world has to offer. After the end, it tended to forget him until, in 1991, a large and probing retrospective opened at the Metropolitan Museum. There, the big news was that Davis had entered a heroic phase in the underappreciated last decade of his life, during which he had produced some of his finest work. A new generation of scholars was claiming for him a seminal role in everything from Abstract Expressionism to Pop, Color Field painting and conceptual word works. In the 1990s he might well be seen as a forerunner of the current batch of political activist artists.

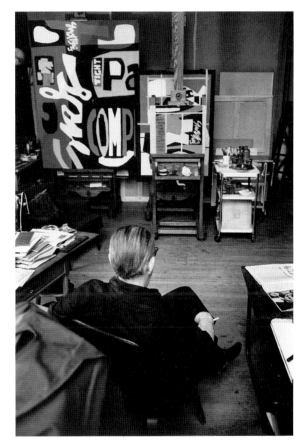

The ever fastidious and cantankerous Davis, who once called himself a "Colonial Cubist," probably would deny most of it, although he would be pleased.

He'd be both right and wrong.

The essential Stuart Davis is great not because of his historical influence. He's great because he got a persistent piece of modern American life down just right. Like Edward Hopper, he's indispensable.

What makes him that way are personal virtues associated with the best in the American spirit. One of these is the belief that the game's not over until it's over. Late in life Davis was already ill. His reputation was secure. He could have coasted. Instead, **23** he produced the best art of his life, beginning with *Visa* of 1951 and ending with the **34** great *Blips and Ifs* of 1964.

Not quite ending. Davis had the tenacity of a pit bull. He had long derived inspiration from an old photograph of a French chateau. He used it as the basis for a number **35, 36** of compositions, such as *Punch Card Flutter*. A painting called *Fin* was found on his easel after his death. The composition is based on the same photograph. With the landscape here turned on its side, the upright tree in the picture seems a fallen tree, a movement played up by the collapsing word "front" and the painted, topsy-turvy "OWH!" beneath it. Sick as he was, the artist hadn't lost his sense of drama and mordant humor. The painting is like a don't-weep-for-me jazz funeral with a French ending.

Fin. Cut. Print it.

Stuart Davis in his studio
Photograph by Dan Budnik

1
ROCKPORT BEACH, 1916
Oil on canvas
30 x 24 inches
Collection Earl Davis
Courtesy of Salander-O'Reilly Galleries

2
STUDIO INTERIOR, 1917
Oil on canvas
18¾ x 23 inches
Courtesy Joan T. Washburn Gallery, New York

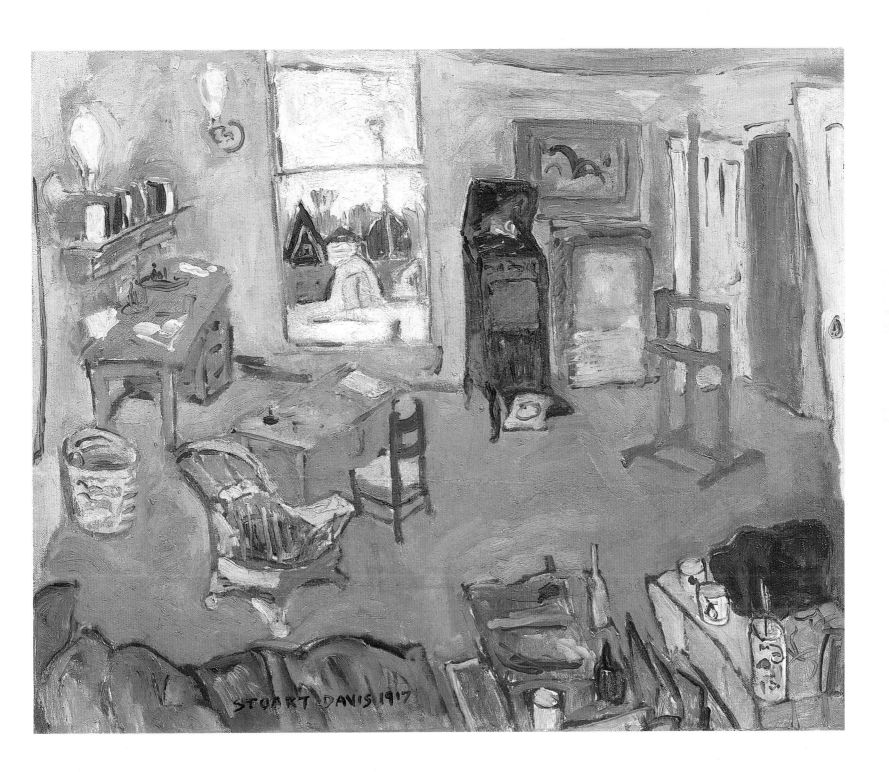

3
SELF-PORTRAIT, 1919
Oil on canvas
22¼ x 8¼ inches
Amon Carter Museum, Fort Worth

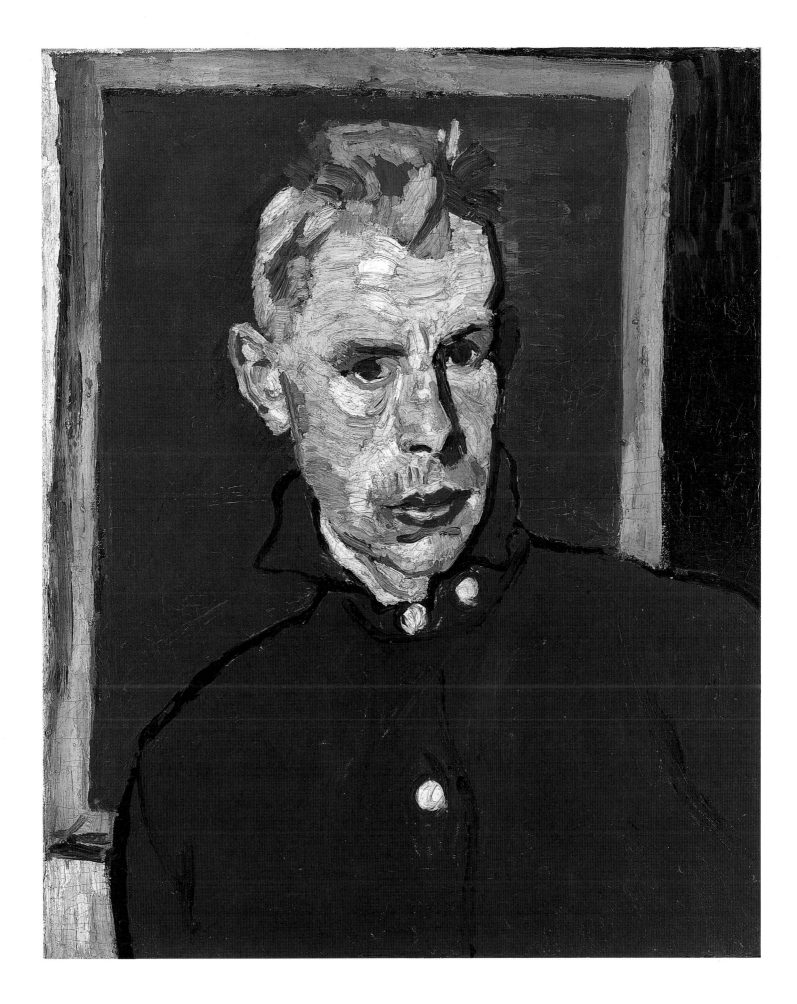

4
CIGARETTE PAPERS, 1921
Oil, bronze paint and pencil on canvas
19 x 14 inches
The Menil Collection, Houston

While still in the midst of retooling himself from an Ashcan realist to
a modernist, Davis did his first paintings to achieve that rare estate of
historical reverberation to both past and future. This one, with its yellow-
ing patina and nostalgic emblems, harks back to the work of 19th-century
American trompe l'oeil artists such as John Frederick Peto updated
through Parisian collage.

5
STILL LIFE (RED), 1922
Oil on canvas
50 x 32 inches
Collection Earl Davis
Courtesy of Salander-O'Reilly Galleries

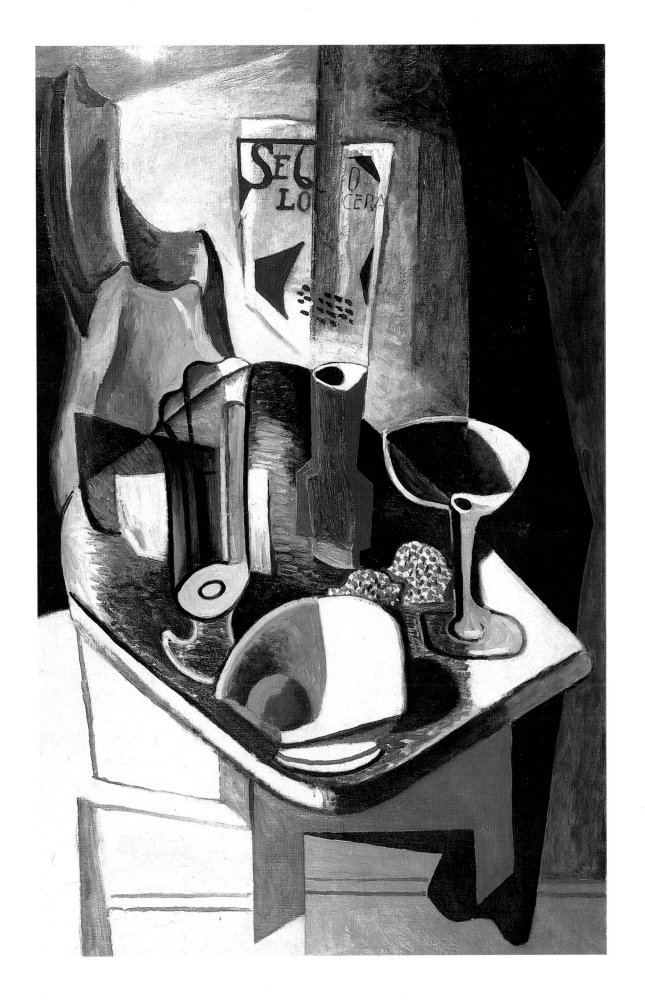

6
LUCKY STRIKE, 1924
Oil on paper board
18 x 24 inches
Hirshhorn Museum and Sculpture Garden
Smithsonian Institution, Washington, D.C.
Museum Purchase, 1974

Startlingly prescient of 1960s Pop, this work shows Davis's ability to wed visual autobiography to social commentary. In his day smoking represented macho and Davis, a serious addict, used the motif repeatedly. The tabloid paper and cartoon is like a diary entry recalling his own background in newspaper illustration. The work is small but has the scale of a billboard in the desert. That suggestion of larger social issues was confirmed by Davis's crack, "I do not belong to the human race but am a product made by the American Can Co. and the New York Evening Journal." Such pith recalls H. L. Menken, who Davis sometimes resembled in both blowsy appearance and curmudgeonly temperament.

7
EDISON MAZDA, 1924
Oil on cardboard
24½ x 18⅝ inches
The Metropolitan Museum of Art
Purchase, Mr. and Mrs. Clarence Y. Palitz, Jr.
Gift in memory of her father, Nathan Dobson, 1982

As Davis's work developed he was less and less inclined to leave anything
to chance. But there are Dadaesque overtones in this image simply
through his selection of subject matter. What would have been a wine
bottle in Leger or Gris here becomes a curvaceous light bulb. The odd
selection of motif echoes the use of found objects such as Marcel
Duchamp's urinal in *Fountain*. Both Davis and Duchamp call attention
to commonplace objects. They tend to be of the sort we do not notice
by unspoken social agreement. Perhaps that agreement exists because
when we pay attention we are forced to acknowledge the
objects' cool feminine fecundity and to wonder why designers give a
sexual charge to objects of use. Artists like Davis, Duchamp, and Picabia
noticed this long before other observers identified the erotic overtones
of, for example, automobile design.

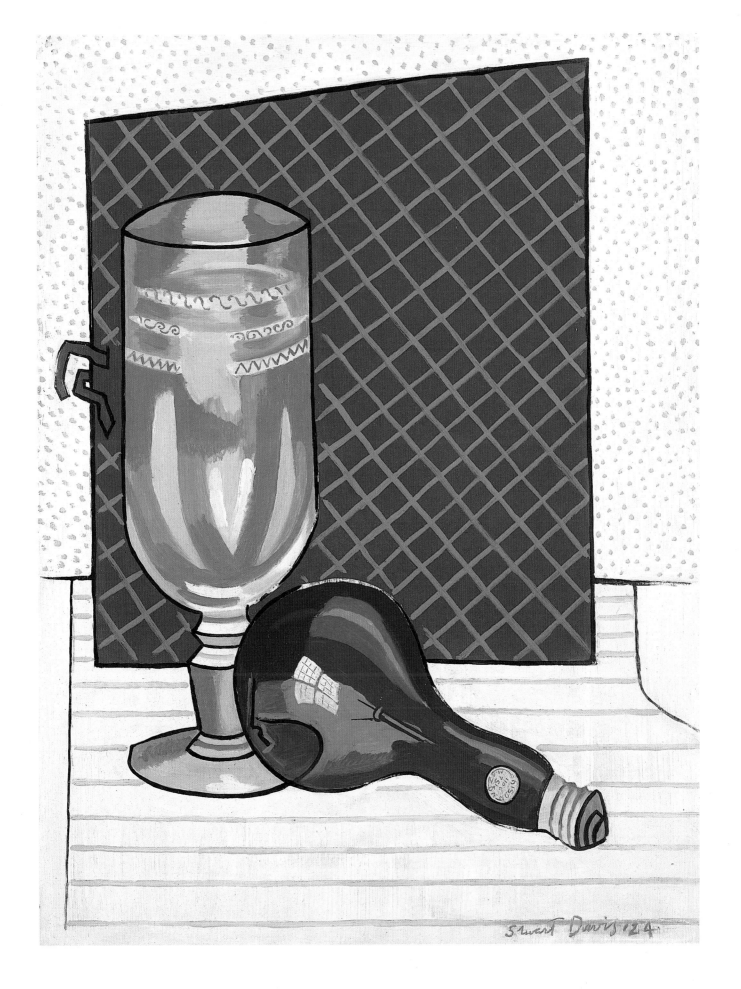

8
ODOL, 1924
Oil on canvas board
24 x 18 inches
Andrew J. Crispo Collection

Consumerism replaced religion in the modern world and Davis lost no time in both deifying and deriding its new icons. In Odol's civilization one is not absolved by holy waters—it's the cleansers that purify. Deification comes through symmetrical composition echoing coats of arms of the Middle Ages. Derision derives from the use of clunky shapes and funky color combinations. What sets Davis's work apart is his canny use of the visual vernacular.

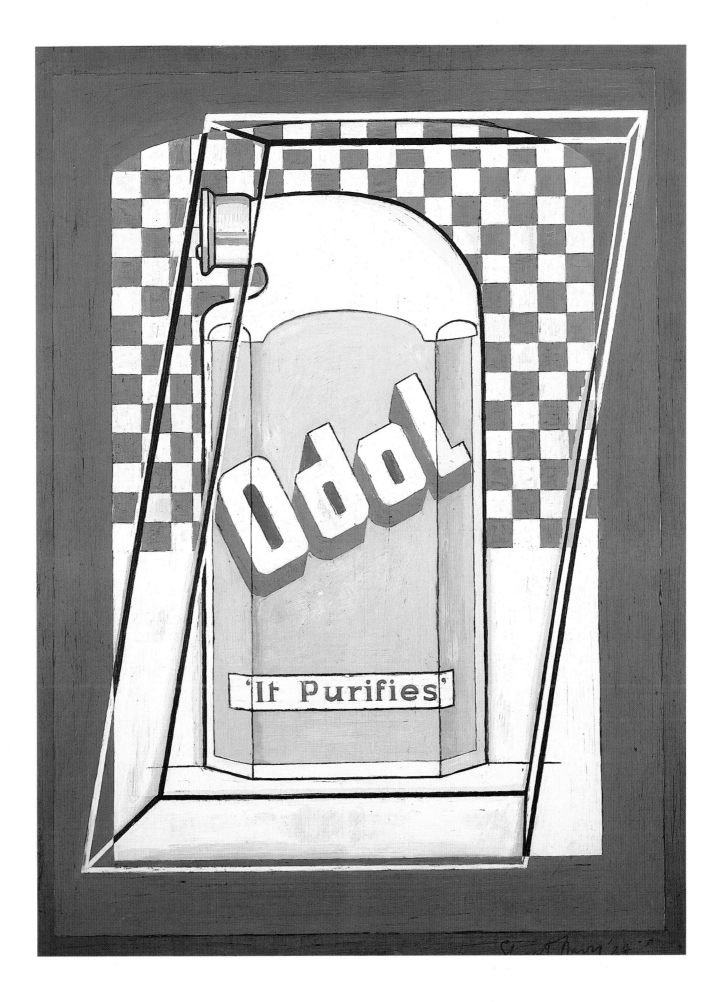

9
EARLY AMERICAN LANDSCAPE, 1925
Oil on canvas
19 x 22 inches
Whitney Museum of American Art, New York
Gift of Juliana Force, 31.171

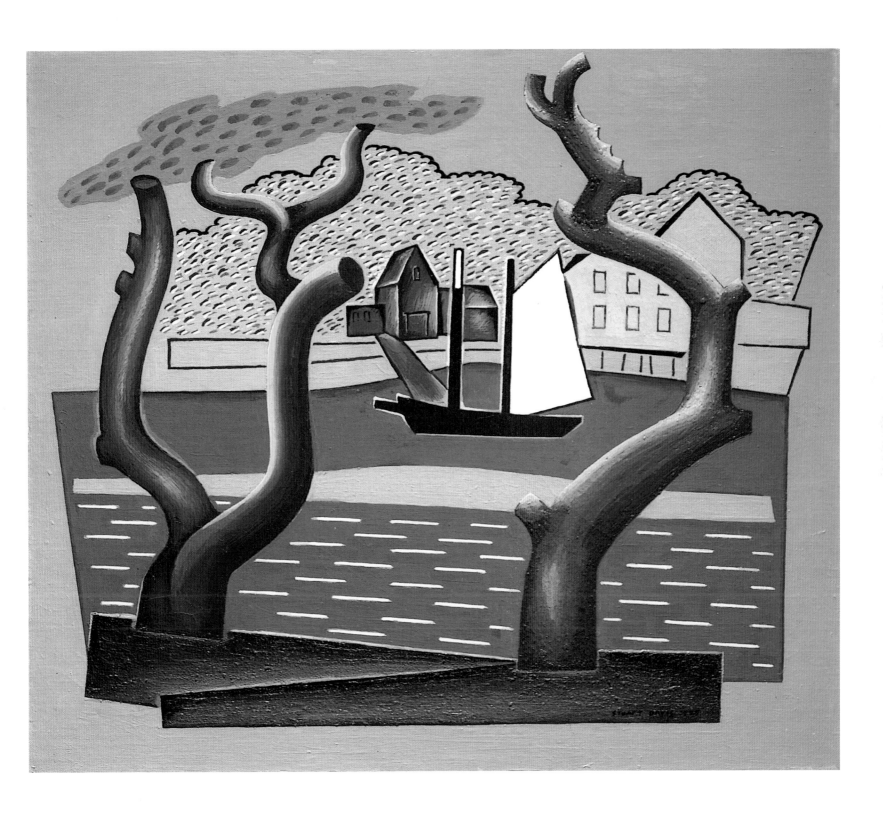

10
PERCOLATOR, 1927
Oil on canvas, 36 x 29 inches
The Metropolitan Museum of Art
Arthur Hoppock Hearn Fund, 1956

Funk gives way to honed elegance. Here, experiments with Cubism come
close to pure abstraction, but Davis retains spatial illusion that hints
at subject matter. In later years the artist reworked this composition
into *Owh! in San Pao*. **25**

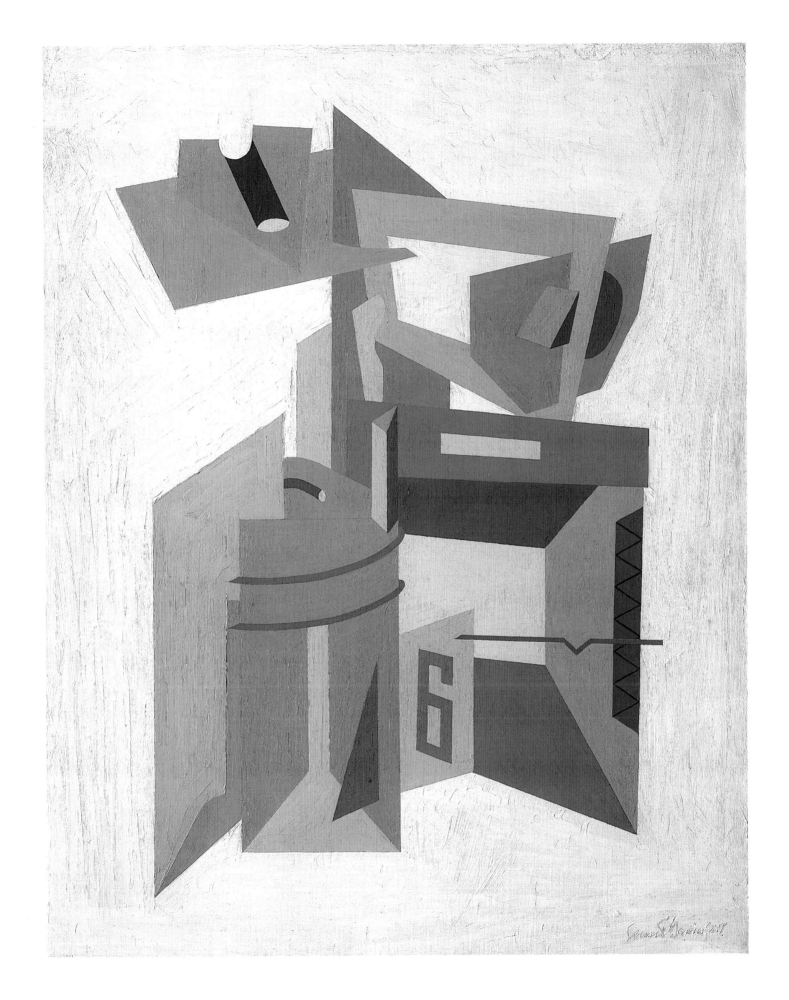

11
EGG BEATER NO. 4, 1928
Oil on canvas
27 x 38⅛ inches
The Phillips Collection, Washington, D.C.

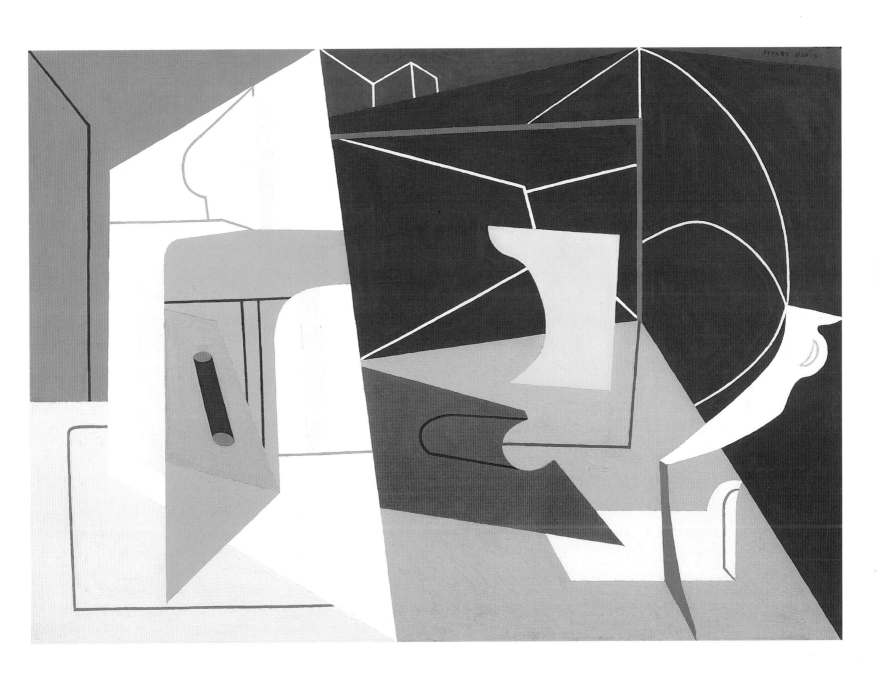

12
EGG BEATER NO. 5, 1930
Oil on canvas
50⅛ x 32¼ inches
The Museum of Modern Art, New York
Abby Aldrich Rockefeller Fund

Clearly influenced by his stay in Paris, this witty Eggbeater variant com-
bines a Braque-like mandolin with Davis's antic kitchen utensil. Its visual
punning is worthy of Saul Steinberg and may also reflect the dawning
modernist neo-classicism being ushered in by Picasso's classical phase
and the popularity of artists like André Derain and Balthus.

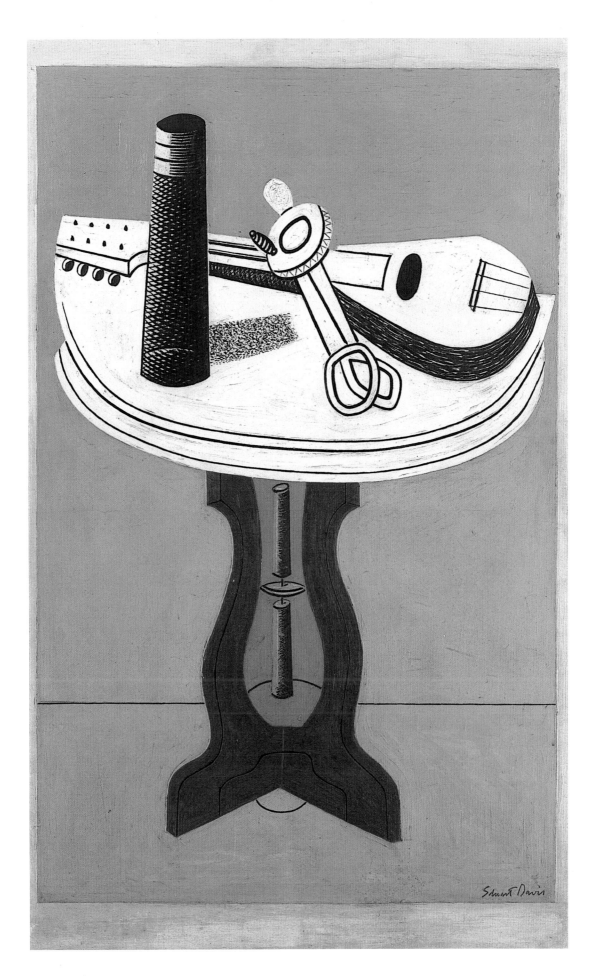

13
SUMMER LANDSCAPE, 1930
Oil on canvas
29 x 42 inches
The Museum of Modern Art, New York
Purchase

A serene image of a Massachusetts seaport summer in pastel hues, this composition grows unmistakably from Davis's Parisian street views, but shows that the artist had looked at more than just the scenery, he'd looked at French modernism as well. The exceptional stability and relaxation here likely comes from Davis's dawning admiration for Georges Seurat, and its industrial aura from his sensed affinity with Fernand Léger.

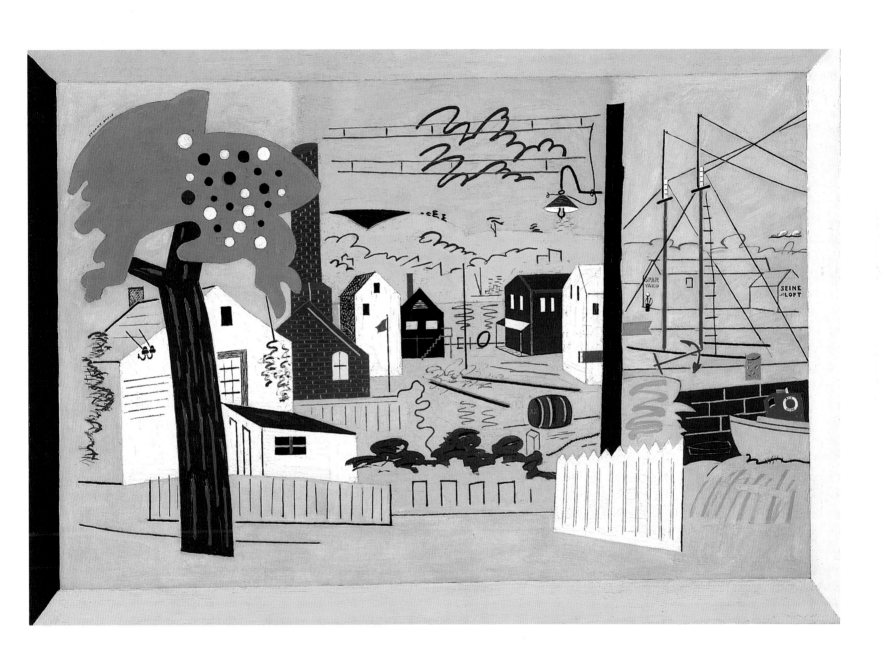

14
SALT SHAKER, 1931
Oil on canvas
49⅞ x 32 inches
The Museum of Modern Art, New York
Gift of Edith Gregor Halpert

Davis's deadpan humor was so naturally close to the Dada spirit that
it just keeps turning up in his work. There is no mistaking the reference
to a figure here or the fact that the "head" also suggests a semaphore.
The eye-stinging proto-Op Art background makes the eyes feel like what
happens if you're dumb enough to open them in the briny.

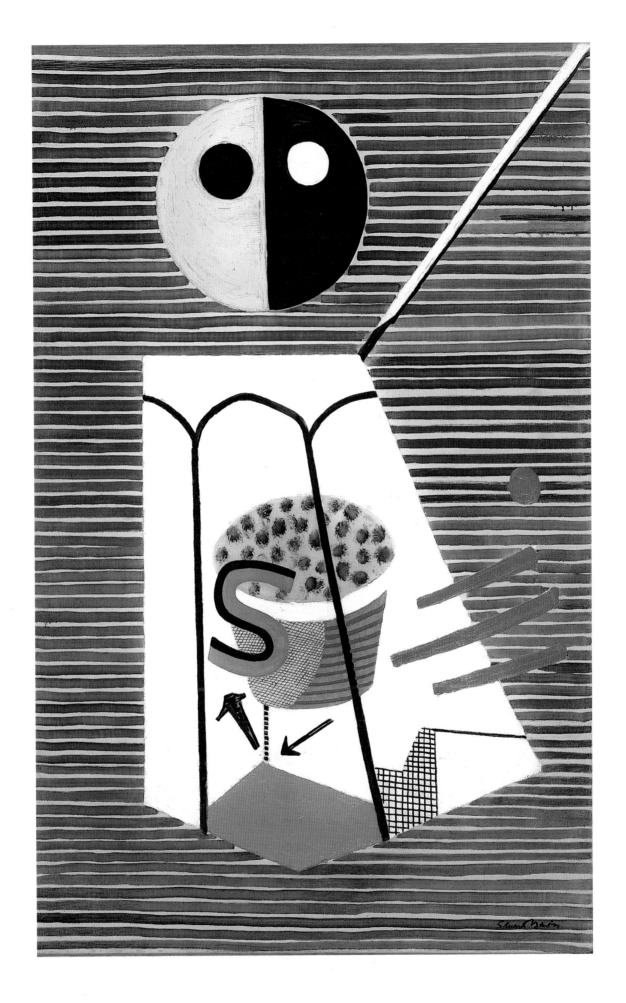

15
STILL LIFE: RADIO TUBE, c. 1931
Oil on canvas
50 x 32⅛ inches
Rose Art Museum, Brandeis University, Waltham, Massachusetts
Bequest of Louis Schapiro

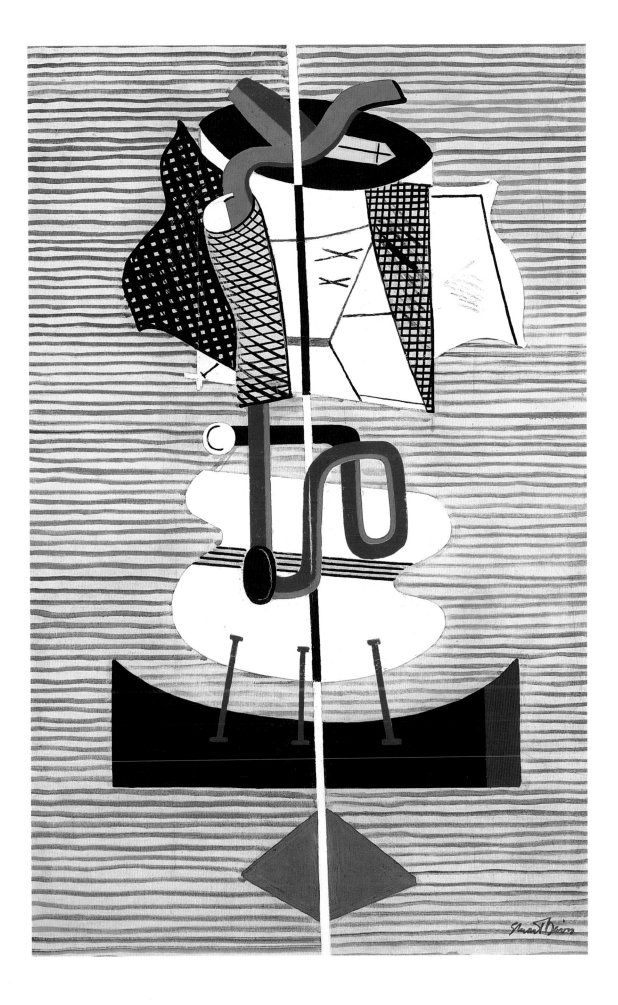

16
NEW YORK MURAL, 1932
Oil on canvas
84 x 48 inches
Norton Gallery, West Palm Beach, Florida

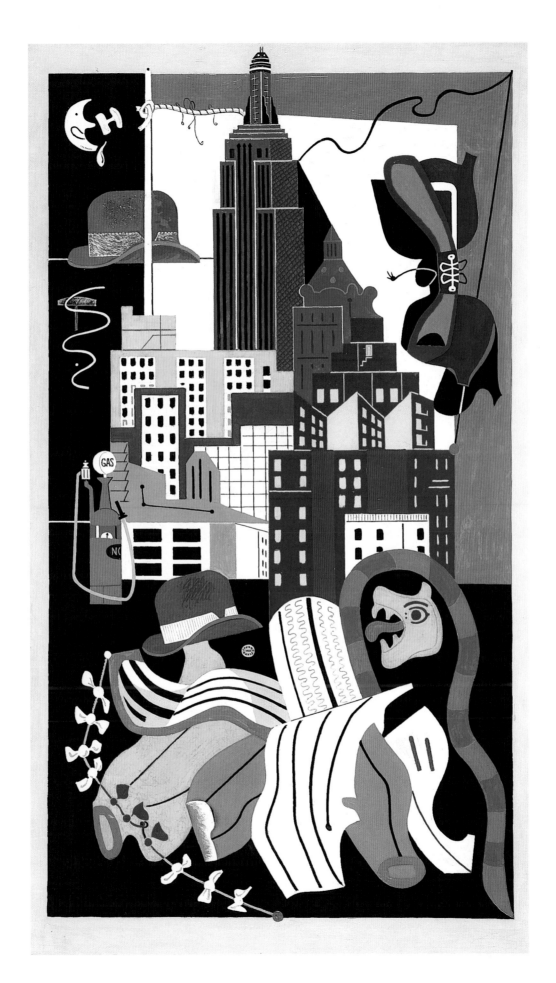

17
MURAL (RADIO CITY MEN'S LOUNGE MURAL:
MEN WITHOUT WOMEN), 1932
Oil on canvas
10 ft. 8⅞ inches x 16 ft. 11⅞ inches
The Museum of Modern Art, New York
Gift of Radio City Music Hall Corporation

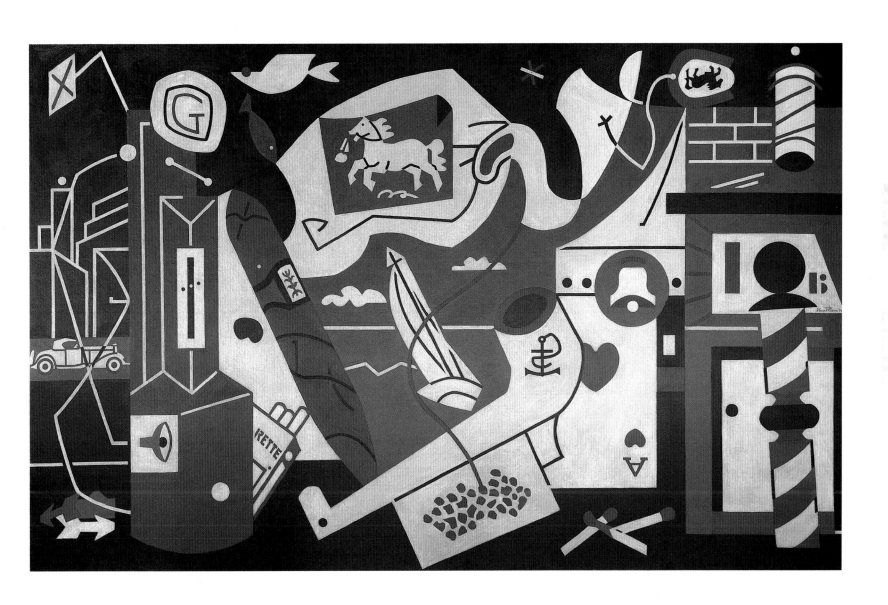

18
SWING LANDSCAPE, 1938
Oil on canvas
86¾ x 172⅛ inches
Indiana University Art Museum, Bloomington

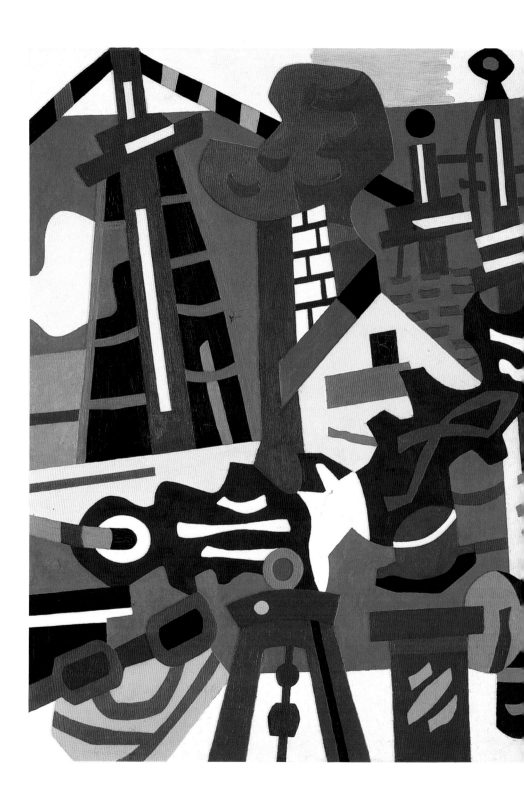

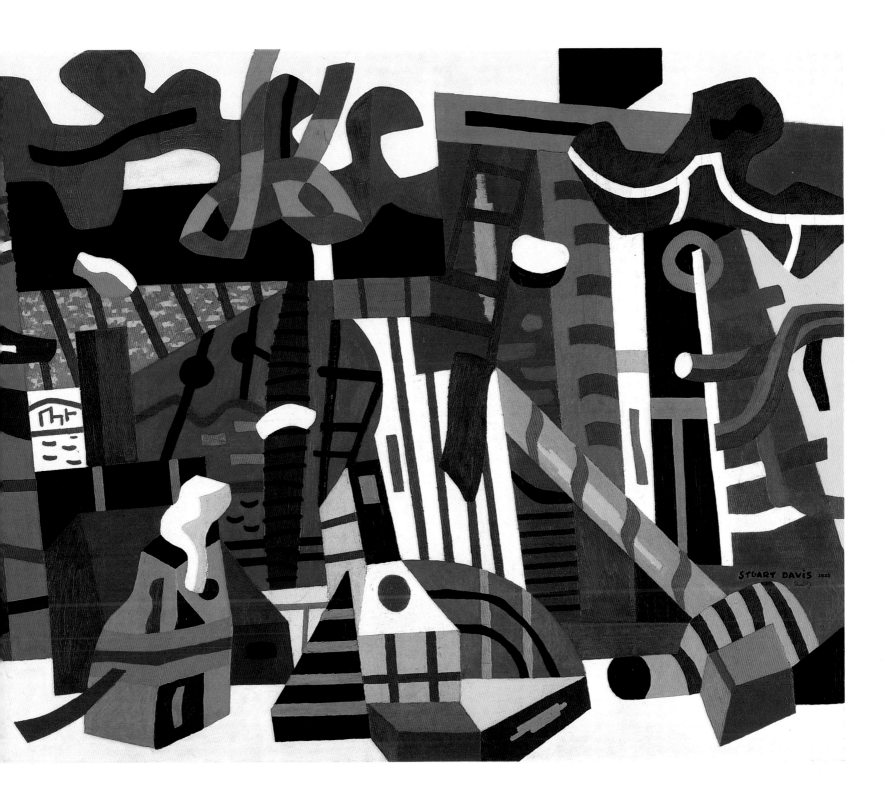

19
REPORT FROM ROCKPORT, 1940
Oil on canvas
24 x 30 inches
The Metropolitan Museum of Art
Edith and Milton Lowenthal Collection
Bequest of Edith Abrahamson Lowenthal, 1991

As Davis entered a period of withdrawal and reflection following his disillusionment with social activism he painted canvases, like this one, that appear newly complex and ornate. A far cry from his early pastoral views of Rockport, they now emphasize the effect of urban industry on small towns with their gas pumps and garages. The word "Seine" alludes to both his debt to French art and his growing internationalism. Despite cheery efforts, this is not a happy picture. Its world is unglued and drifting apart.

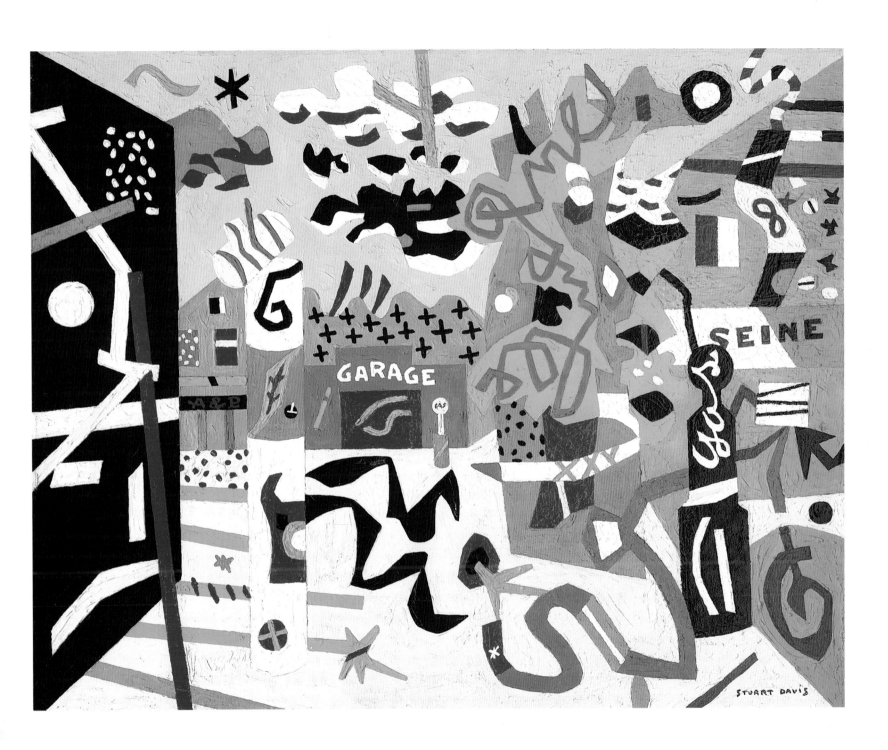

20
ARBORETUM BY FLASHBULB, 1942
Oil on canvas
18 x 36 inches
The Metropolitan Museum of Art
Edith and Milton Lowenthal Collection
Bequest of Edith Abrahamson Lowenthal, 1991

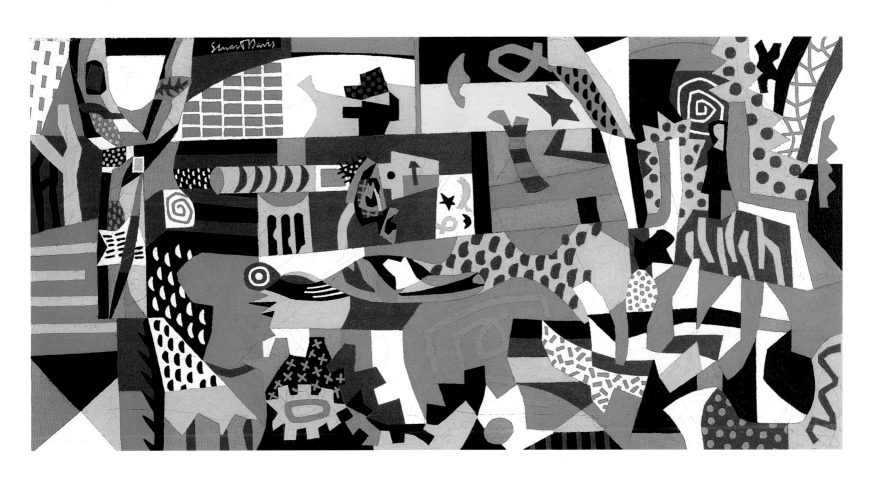

21
G & W, 1944
Oil on canvas
18¾ x 11⅝ inches
Hirshhorn Museum and Sculpture Garden
Smithsonian Institution, Washington, D.C.
Gift of the Marion L. Ring Estate, Washington, D.C., 1988

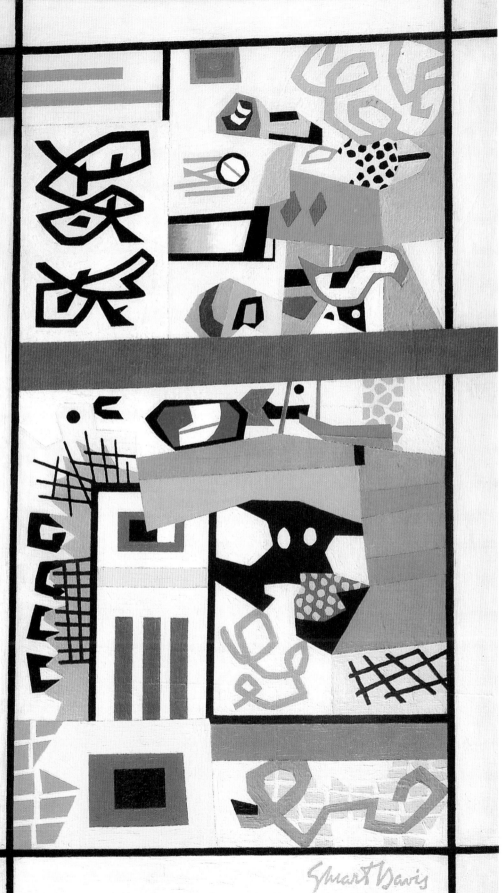

Stuart Davis

22
THE MELLOW PAD, 1945/51
Oil on canvas
26 x 42 inches
The Brooklyn Museum, New York
Bequest of Edith and Milton Lowenthal

The date on this painting shows Davis lingering increasingly longer over his work. A certain similarity in spirit reflects, among other things, thoughts of Piet Mondrian. Davis had known the great Dutch purist when he came to New York as a refugee in World War II. They were fellow jazz buffs who, as artists, agreed that "Nature was a great thing if you don't get mixed up in it."

Mondrian died in 1944, and it's possible to read *G & W* as a homage since it so pointedly borrows a Mondrian grid for its superstructure. One can relate *The Mellow Pad* to Mondrian's late masterpiece, *Broadway Boogie Woogie*. Both paintings use complex structure to evoke urban jazz and syncopation.

By now Davis was integrating words as parts of composition, even using his distinctive signature as a riff in the improvisation. It also seems certain, given the impacted nature of the New York art world, that he had Jackson Pollock on his mind. By now Pollock was well into his great series of dribble paintings. Based on such art, the critic Harold Rosenberg had redefined artists like Pollock as existential matadors and the canvas as an "arena in which to act." Davis certainly was aware of that when he defined his *Pad* series as "a cool spot at an arena of hot events."

Even an emotion as sour as envy can produce great art.

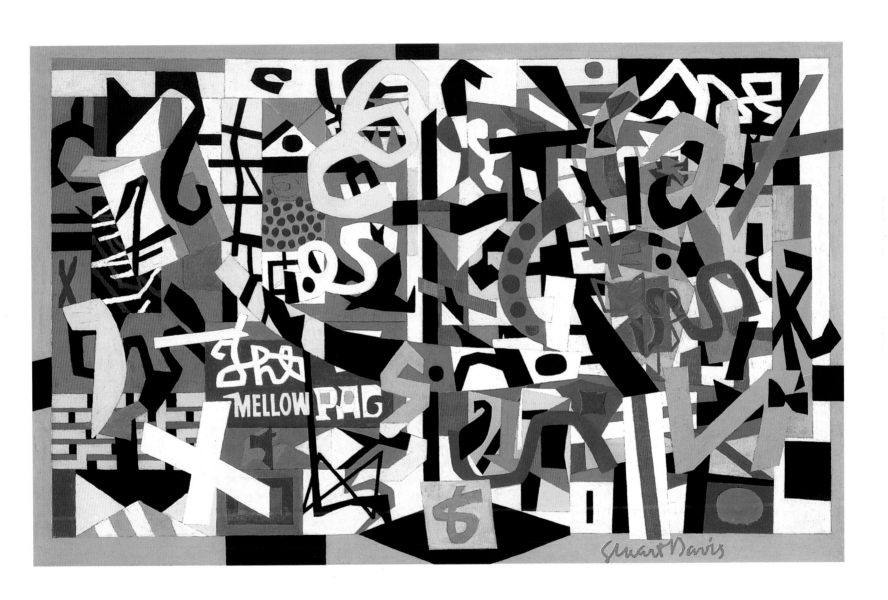

23
VISA, 1951
Oil on canvas
40 x 52 inches
The Museum of Modern Art, New York
Gift of Mrs. Gertrud A. Mellon

In the 1950s Davis began his final heroic phase with paintings like this
one based on a matchbook cover advertising spark plugs. Davis was
by now a fixed icon in American art along with artists like Alexander
Calder and Isamu Noguchi. But ever alert to the competition, he felt
embattled by the growing triumph of Abstract Expressionism. He
challenged its grand rhetoric of large forms and large canvases by
using bolder forms and greater scale himself. The word "Champion"
and the phrase "The Amazing Continuity" are no doubt self-referential.
They are also ironic. American business trumpets itself as the world
winner on a humble, throwaway matchbook cover. In these works Davis
jumped ahead of the action painters to the cool popsters of the 1960s.
One thinks of Ed Ruscha's *Standard Station*. Champions and Standards
disappear in time.

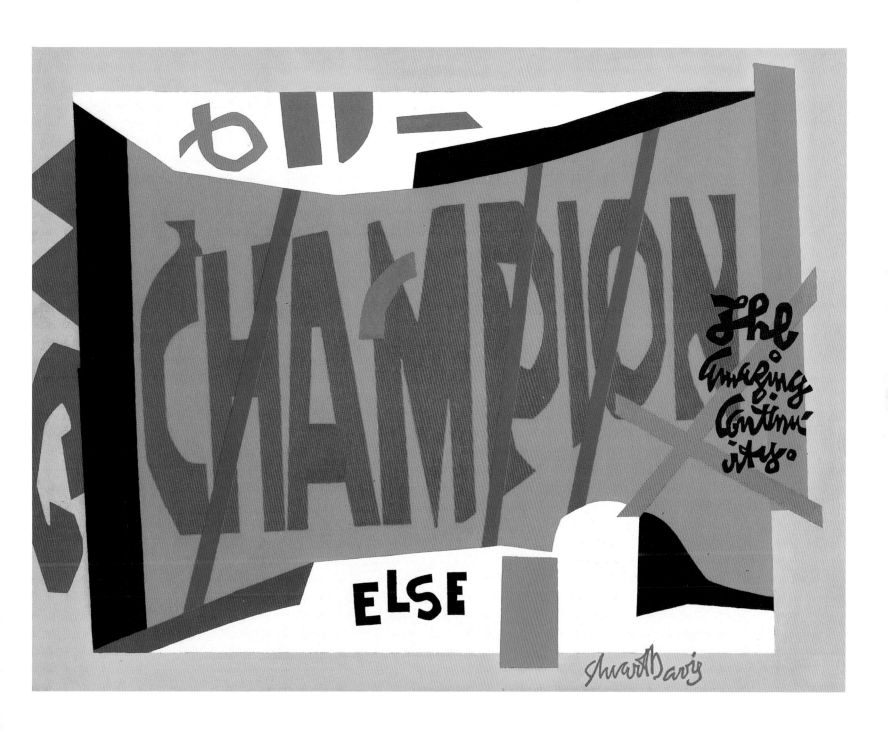

24
SCHWITZKI'S SYNTAX, 1961
Oil, wax emulsion and masking tape on canvas
40 x 52½ inches
Yale University Art Gallery, New Haven, Connecticut
The Katherine Ordway Fund

Done ten years after *Visa*, this variation on the *Champion* theme shows how Davis made a more aggressive composition through cropping and color changes.

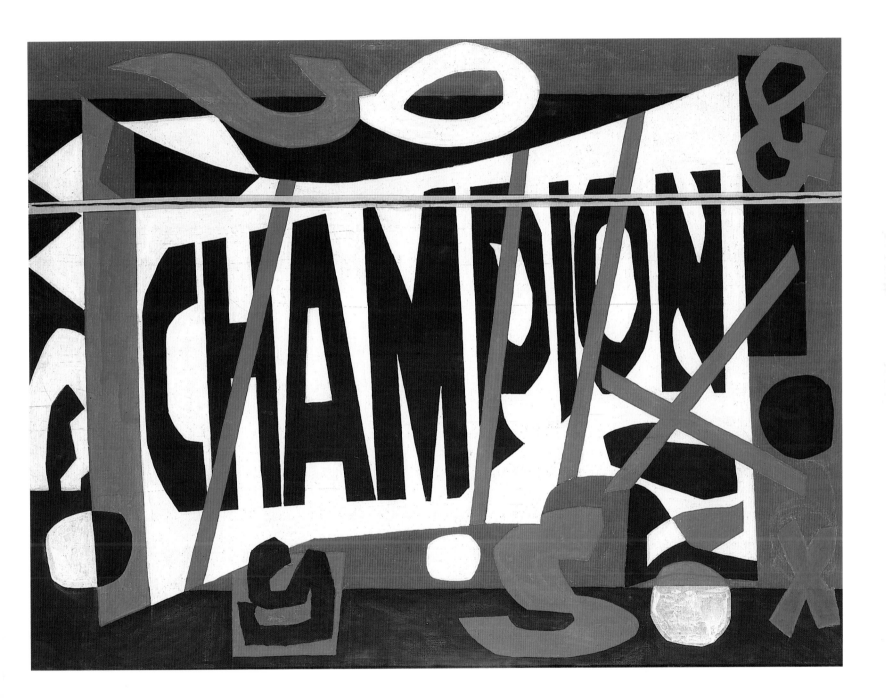

25
OWH! IN SAN PAO, 1951
Oil on canvas
52¼ x 41¾ inches
Whitney Museum of American Art, New York
Purchase, 52.2

This composition shows Davis's growing habit of returning to older
works, not in exhausted self-parody, but as the basis for new ideas.
Here he harks back to *Percolator* of 1927. A comparision finds the **10**
earlier, cooler composition galvanized to action with exclamatory words
used as improvisational solos. Davis didn't intend his words as rebuses,
but it's hard not to read "Now or Else!" into this painting. The title
commemorates his invitation to participate in the São Paulo Bienial.

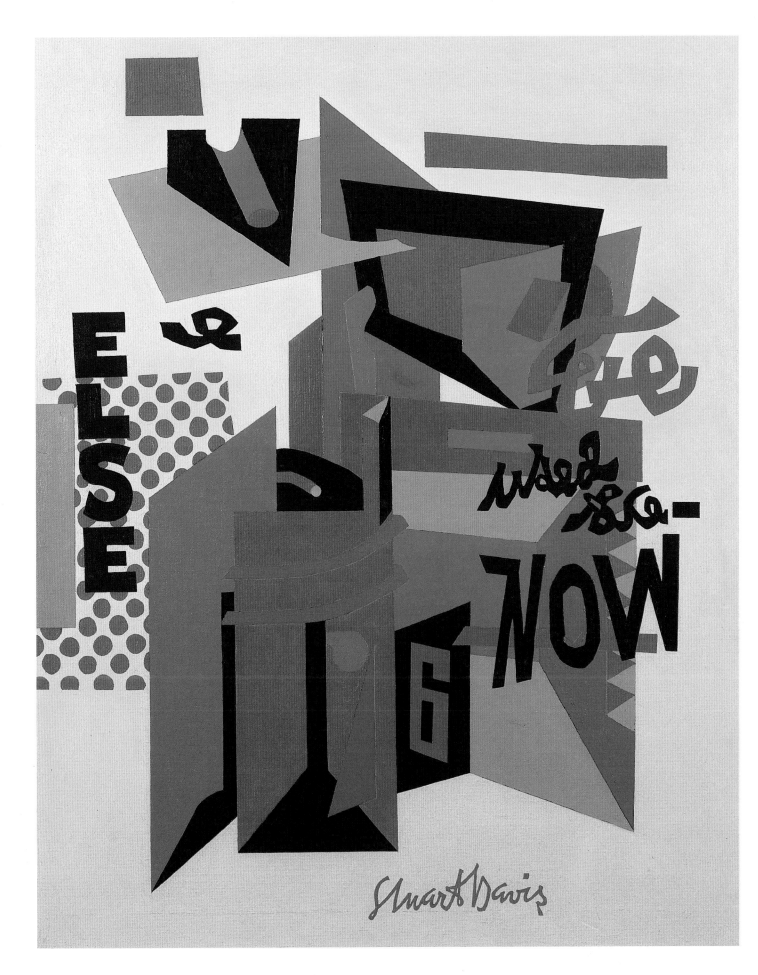

26
RAPT AT RAPPAPORT'S, 1952
Oil on canvas, 52 x 40 inches
Hirshhorn Museum and Sculpture Garden
Smithsonian Institution, Washington, D.C.
Gift of the Joseph H. Hirshhorn Foundation, 1966

RAPT AT RAPPAPORT'S

27
MIDI, 1954
Oil on canvas
28 x 36¾ inches
Wadsworth Atheneum, Hartford, Connecticut
The Henry Schnakenberg Fund

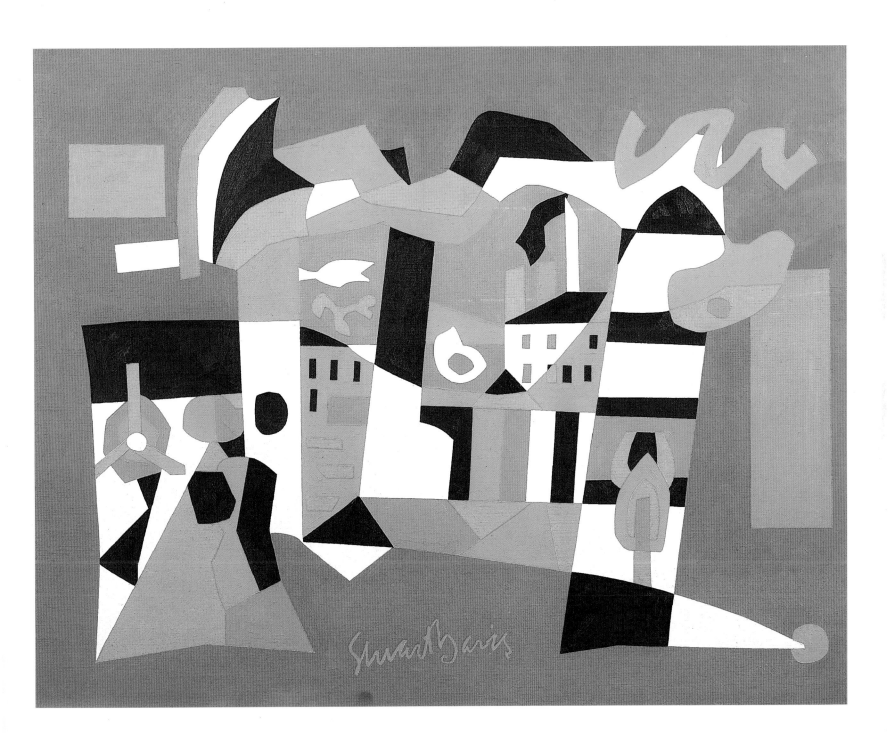

28
COLONIAL CUBISM, 1954
Oil on canvas
44⅞ x 60⅛ inches
Walker Art Center, Minneapolis, Minnesota
Gift of the T. B. Walker Foundation, 1955

Thank goodness Davis was indeed a "colonial." It's hard to imagine
the suave, rational, French part of his art without its Yankee zing.

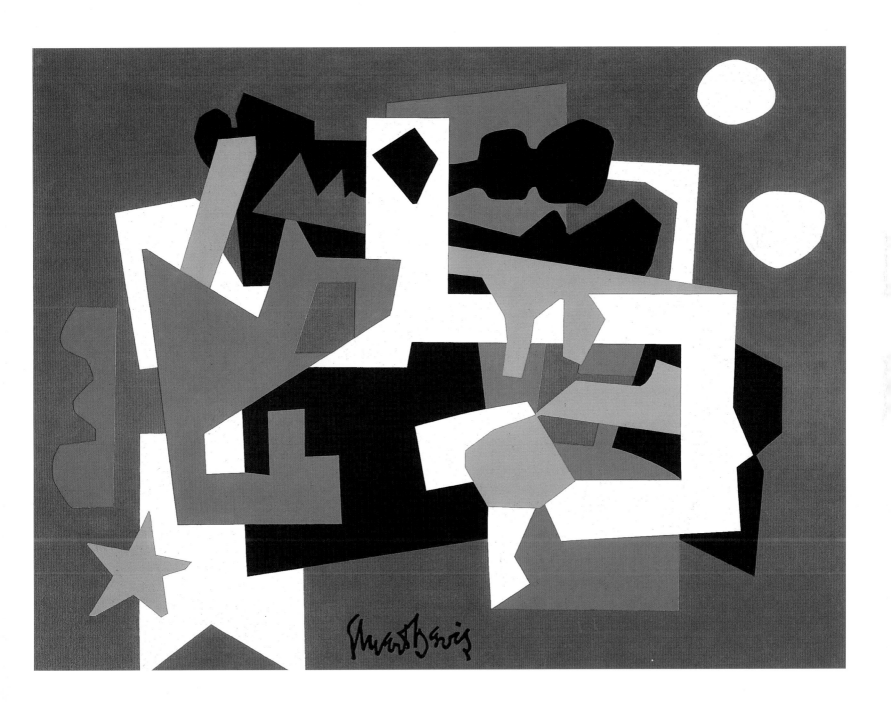

29
ALLÉE, 1955
Oil on canvas
96 x 396 inches
Drake University, Des Moines, Iowa

Here is Davis's French classicism at its purest. It has zap, but without his usual visual argot. Maybe the high school dropout painter was a little intimidated by the academic setting. He was certainly conscious of the relationship between such a large painting and its architectural surroundings. The campus's main architect, Eero Saarinen, commissioned the work and Davis wanted to get it right. Never able to resist a pun, he meant "Allée" to have its usual sense of indicating a long lane and also to imply the sound-alike French imperative of the word "go," *allez*. There are hints of future Minimalism here in the purist absence of subject and in the flat, clean forms.

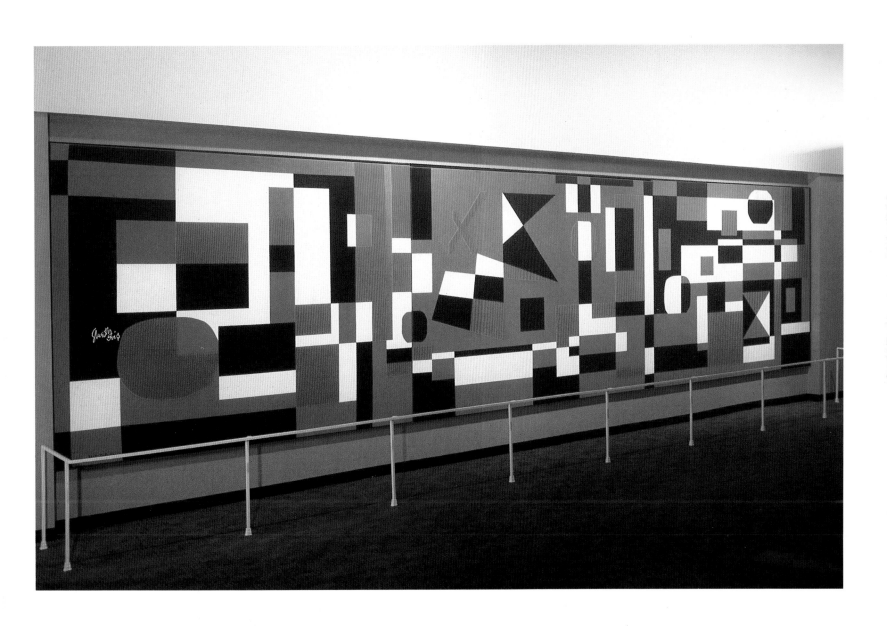

30
TROPES DE TEENS, 1956
Oil on canvas
45¼ x 60¼ inches
Hirshhorn Museum and Sculpture Garden
Smithsonian Institution, Washington, D.C.
Gift of the Joseph H. Hirshhorn Foundation, 1966

Titled with a multi-layered pun, this painting has the fascination of an enigma. Uncharacteristically figurative, it has tempted speculation that the gang of guys in the background could be Davis and some friends. If so they would be regarding the foolishly glamorous woman shown close up. The word "No!" is emphatically placed next to her as if she spoke it. Her far eye forms part of a racing plane's wheel. The picture was first executed as *American Painting* in 1931, but when it was badly received Davis overpainted it and reworked it in the present version. The more one looks the more clearly it seems to be about sexual tension and lurking violence as seen in very early works like *The Front Page*. A line from Duke Ellington lettered in the original version could be read as a sexual allusion — "It don't mean a thing if it ain't got that swing."

31
STELE, 1956
Oil on canvas
52½ x 40½ inches
Milwaukee Art Museum
Gift of Mr. and Mrs. Harry Lynde Bradley

33
PREMIERE, 1957
Oil on canvas
58 x 50 inches
The Los Angeles County Museum of Art

In 1956 Davis was commissioned by *Fortune* magazine to concoct a painting on the theme of "the glamour of packaging." He went to a grocery store, bought a bag of common household products, and distilled the essence of supermarket hucksterism out of the mix. Using such cliché come-ons as "New," "Free," and "100%" he came up with a painting that does more to risibly subvert packaged glamour than to promote it.

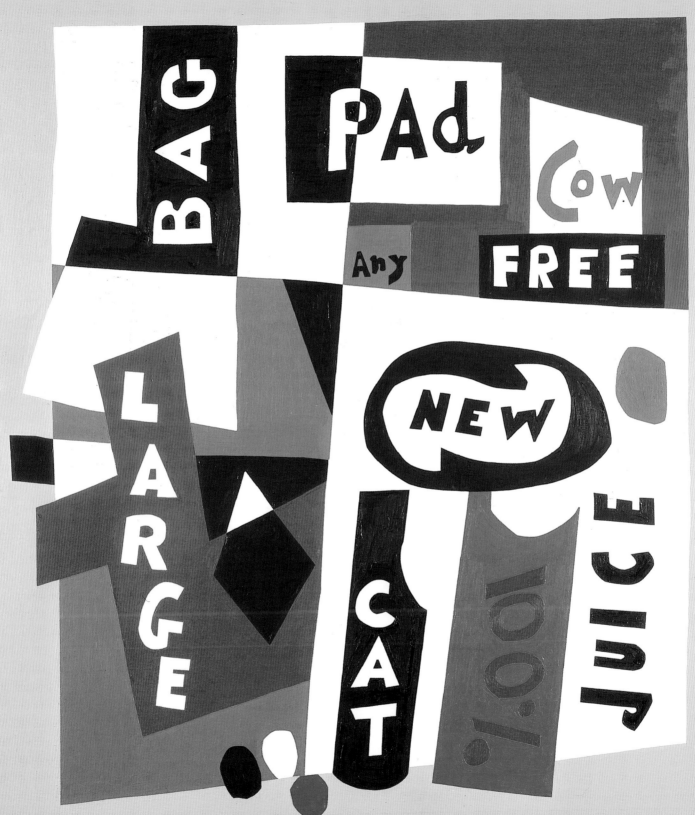

34
BLIPS AND IFS, 1963/64
Oil on canvas
71⅛ x 53⅛ inches
Amon Carter Museum, Fort Worth, Texas
Acquisition in Memory of John de Menil, Trustee, 1961–1969

The incipient sense of film animation that informs so much of Davis's oeuvre comes dramatically clear when this work is compared to *Standard Brand*, 1961. Its syncopated energy is completely rationalized in this work. Like Matisse's late collages, each piece of the composition could easily be cut out whole with a pair of scissors and moved around under an animator's camera. Most noticeable in the comparison is that *Blips and Ifs* is so strikingly transformed by simply becoming little more than a cinematic close-up of its predecessor. Davis added a couple of shapes, the pipe motif and, significantly, the word "tight."

He really knew what he was doing.

35
PUNCH CARD FLUTTER, 1963
Oil on canvas
24 x 30 inches
Collection Earl Davis
Courtesy of Salander-O'Reilly Galleries

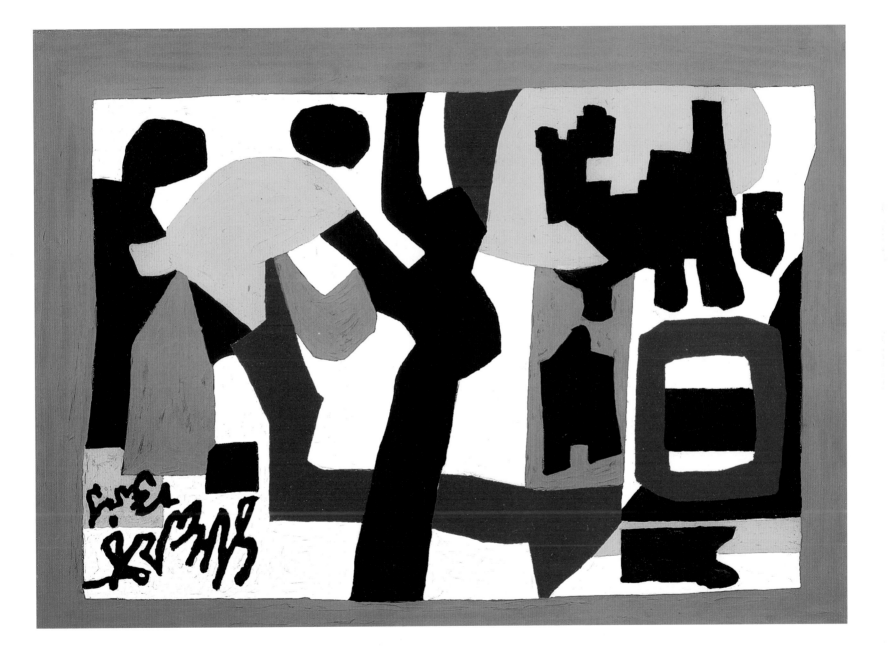

36
FIN (LAST PAINTING), 1964
Oil on casein, wax emulsion and masking tape on canvas
55⅞ x 39¾ inches
Collection Earl Davis
Courtesy of Salander-O'Reilly Galleries

SELECTED BIBLIOGRAPHY

Books and Catalogues

James Johnson Sweeney. *Stuart Davis*. Exhibition catalogue. New York: Museum of Modern Art, 1945.

Eugene C. Goosen. *Stuart Davis*. New York: George Braziller, 1959.

Diane Kelder, ed. *Stuart Davis*. New York: Praeger, 1971. A valuable anthology of Davis's own writings plus contemporary articles and critiques on the artist.

Karen Wilken. *Stuart Davis*. New York: Abbeville Press, 1987. A coffee-table format book on the artist by a leading scholarly expert.

Henry Adams. *Thomas Hart Benton: An American Original*. New York: Alfred A. Knopf, 1989. A fair, sympathetic biography of the master Regionalist, this book provides insight into Benton's rival and a balanced account of their feud.

Lowry Stokes Sims. *Stuart Davis: American Painter*. New York: Metropolitan Museum of Art, distributed by Harry N. Abrams Inc., 1991. This book acted as the catalogue for the Met's Davis retrospective and includes essays by William C. Agee, Robert Hunter, Lewis Kachur, Diane Kelder, John R. Lane, Lisa J. Servon and Karen Wilkin.

Recent Articles

Bennett Schiff. "Stuart Davis Was Modern Right Down to His Very Roots." *Smithsonian*, Dec. 1991.

Peter Plagens. "Stuart Davis: A Retrospective." *Newsweek,* Jan. 6, 1992.

Robert Hughes. "Seeing Life in a Jazz Tempo." *Time,* Jan. 20, 1992.

Diane Kelder. "Stuart Davis, All That Jazz." *ARTnews,* Feb. 1992.

Holland Cotter. "Swing Cubism." *Art in America,* Sept. 1992.

Stuart Davis, 1957, photograph by Arnold Newman